MURDER & MAYHEM
IN
ROCKFORD
ILLINOIS

KATHI KRESOL

THE
History
PRESS

Published by The History Press
Charleston, SC
www.historypress.net

First published 2015

Manufactured in the United States

ISBN 978.1.46711.915.3

Library of Congress Control Number: 2015949275

To John, who always accompanies me to the dark side, and Sarah, Brandon, Amber, Aryn and Stacy, who always bring me back when I've been there too long.

CONTENTS

CONTENTS

ACKNOWLEDGEMENTS

These things never can be accomplished alone, and I have been blessed with so many wonderful people in my life, so even if you are not mentioned here, please know that you helped make this possible.

My deepest appreciation goes to the staff at Rockford Public Library who have always supported me—even when they couldn't see where I was headed—especially Jean Lythgoe and Jan Carter, who always are ready to help me find my "dead guys."

Thank you to Steve Litteral, Michael Kleen, Sara Bowker, Paul and Lisa Smith, Stephen Osborne, Dale Kaczmarek and Troy Taylor for helping me form the stories and convincing me that people would read them. Thanks to Brandon Reid and the crew at the *Rock River Times* for taking a chance and offering me my own column and all the generous people who have read, tweeted (or re-tweeted), liked and shared my stories. Also thanks to Rebecca Rose and Anna Derocher from the *Rockford Register Star*, both of whom helped me gain access to certain photographs. I would also like to thank Laura Furman and her assistant, Tiffany Arnold, from the Midway Village Museum, who did an amazing job helping me find original photographs.

Last but not least, thank you to my family: my parents, Tom and Bette Saunders, who gave me a love for history; my wicked stepmother, Sharon, who is anything but; Tom, my brother and website designer, whose help allowed me time to finally finish the stories; and my sister, Mari, who always believed I would. A special thank-you to John Hoblit, who not only edits my stories and cares enough to ask the hard questions but is also always willing

ACKNOWLEDGEMENTS

to head down any path, bring me coffee and keep the car running in case I need to make a quick escape. Thanks to my children—Sarah, Brandon, Amber, Stacy and Aryn (thanks for the photography shoot!)—you are my light and inspiration.

INTRODUCTION

Rockford, Illinois, was settled in 1834 when three men—Germanicus Kent, Thatcher Blake and Lewis Lemon—decided that this place looked like a good one to start a business. Charles Church states in his book *The History of Winnebago County*, "They were not drawn to this place for a noble quest for their Country or their King." They were not searching for gold or were exiles from their native land. Their choosing this place above all others was not a romantic adventure. According to Church, Kent wanted to establish a sawmill and Blake wanted to farm. The picturesque area around the Rock River seemed a good place to do both.

These men were the first of many who left their homes far behind as they set out to find the American Dream. They were all searching for a place where they could build better lives for their families. They could have settled anywhere, but they chose to stop and plant their roots here.

People often talk about "the good ol' days," when the streets were safer and people treated one another with a greater respect. Rockford may have had that once, but the dark side has always been just been under the surface. Rockford's history is much like the dangerous waters of the Rock River, which runs through the center of town. The river may look safe and tempting, but there are dangerous undercurrents waiting to trap swimmers and pull them down.

I have heard (and repeated) the line that Rockford never had a time that was tranquil. Basically, people started killing one another as soon as they started to settle here. The first documented killing took place in the summer of 1835, when the mutilated body of an unidentified man was discovered

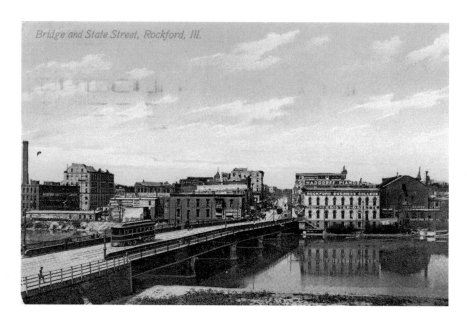

Bridge and State Street, Rockford, Ill.

A postcard showing East State Street in 1910. *From author's collection.*

two miles south of the settlement. He was never identified, and his killing was first blamed on the Native Americans. Later, it was thought that his death occurred over a dispute for a land claim. The crime remained unsolved, and the unfortunate man was buried where he was found.

These stories may share the worst of the people that have called Rockford home, but they also show the best. It is always inspiring that even in the worst possible scenario people show incredible courage, compassion and forgiveness. These stories are about the ordinary person responding to tragedy in extraordinary ways.

Part I
MURDER

Beware the dark pool at the bottom of our hearts. In its icy, black depths dwell strange and twisted creatures it is best not to disturb.
—Sue Grafton

1
THE MURDER OF SHERIFF TAYLOR

Rockford was a pretty wild place in 1856. The city was making advances in what would become the foundation for the manufacturing boom that was to put Rockford on the map. But in the early days, crime was very common; robbery and cattle rustling were especially prevalent.

John F. Taylor was the sheriff in those days. He was, from all accounts, a very fair man. Sheriff Taylor was nearing the end of his term, and Samuel Church had already been chosen as his replacement. Taylor expected the rest of his term to be quiet. Unfortunately, he was wrong. When he left for work on November 11, 1856, he kissed his wife and one-and-a-half-year-old son goodbye as usual; neither could know it would be for the last time.

Sheriff Taylor was alerted to possible cattle thieves in the town when two brothers, Alfred and John Countryman, rode into town with a deal that seemed too good to be true. They were trying to sell a herd of cattle for a sum much lower than market value. The prospective buyers grew suspicious and alerted the sheriff. At around nine o'clock that morning, Sheriff Taylor arrested the brothers for the suspicion of theft. He carried through the usual routine of searching the suspects and found pistol balls in Alfred's pockets, but when he questioned the suspect, Alfred denied having a gun. The sheriff and one of the deputies started to walk toward the jail. Just as they reached the steps, Alfred broke away from the sheriff, leaped over a fence on Elm Street and ran down the street toward Main Street with Sheriff Taylor in pursuit.

The sheriff had almost caught up with Countryman at the livery stable of Hall and Reynolds and was about to grab him when Alfred pulled a

gun and fired at the sheriff. Taylor, hit in the chest, staggered a few steps and gasped out, "I'm shot, catch him." He then fell, mortally wounded.

Alfred Countryman continued to run and made it all the way to Kent Creek before he was brought down by one of the many citizens who took up the chase when Taylor fell. Witnesses would claim the pursuers numbered over one hundred men. There were some on horseback and some on foot, some armed with shotguns and some with rifles. Alfred was caught and put into a police wagon. When they arrived back at the jail, a very large crowd had gathered. They brought a rope with them and threatened to lynch Alfred right there. City officials rushed to the jail, and sheriff-elect Samuel Church arrived. He was able to calm the crowd with promises that justice would swiftly prevail.

The autopsy would show that the pistol ball entered the sheriff's chest and passed through his lung, hitting the aorta. Four quarts of blood had pumped into his chest.

Sheriff Taylor, who was thirty-one when he died, was respected in Rockford, and his funeral definitely reflected that. It was held on the public square under the charge of the Masonic fraternity, of which Taylor was a member. The story of his murder went national.

Alfred Countryman's trial was held in February 1857. The jury found him guilty of murder, and he was sentenced to hang. His execution took place on March 27, 1857, at the farm of the new sheriff Samuel Church "about two miles outside of the city." People crowded into Rockford from all over the country. Two special trains brought riders from Iowa and "intermediate places" to witness this execution.

Countryman was the first man to be publicly executed (officially) in Winnebago County. It was later estimated that eight thousand people came to witness the event. Ironically, extra precautions were taken to make sure that Countryman arrived safely to the execution. After Countryman said goodbye to his wife and mother, he began his trip to the place of execution. There was a procession from the jail—including two fire companies, armed with sabers and rifles—to surround the carriage in which Countryman rode. The procession was described in great detail in the newspaper, with the crowd lined up the whole way from the jail to the execution location. Alfred Countryman rode in the carriage with Sheriff Church; the windows were covered with curtains to deny the crowd a view of him, "not wanting to gratify their morbid curiosity."

Countryman's father, brother, a cousin and sister were there to witness the hanging. Alfred addressed the crowd to beg their forgiveness. His

last words were, "Farewell friends, once more I hope to meet you in a Heavenly land where sorrows be no more! Glory be to God! I am going home!"

Countryman's arms were tied to his side, a black bag placed over his head, "the noose placed around his neck and at seventeen past two the drop fell, and Alfred Countryman was no more." As his body fell through the trap, witnesses remarked that even though the crowd was huge, the only sound that could be heard was the sobbing of Countryman's family.

Sheriff Church addressed the crowd before the body was taken down. "These painful proceedings being now concluded, and the sword of justice about to be returned to its sheath, I hope never again to be drawn with so much severity. I would thank you all for the good order you have maintained, your conduct does credit to the city, and I hope you will observe the same decorum in retiring."

Many might wonder why so many people came, some from far away, to witness this event. The newspapers from that day speculated: "Curiosity, was no doubt, the prime motive which induced their attendance; and those that contend that examples of this kind have effect to deter men from incurring a similar penalty, would be sadly puzzled to determine the effect of the conflicting emotions which stirred the breasts of that vast crowd of spectators who had congregated for the single purpose of seeing a fellow creature die."

Alfred Countryman's body was turned over to his family and taken home to Ogle County to the "Pennsylvania Settlement" and buried there. Unfortunately, Sheriff Church's wish didn't come true, and the need for the sword of justice would arise several more times in the Forest City.

2
HEARTLESS

B ridget Hart held her extensive family of two girls and six boys together after the death of her beloved husband, John. That tragedy had taken place in 1891. The family lived on a farm outside Winnebago on Wolf Grove Road, about six miles away from Rockford.

On September 5, 1893, around three o'clock in the afternoon, Bridget left her home to walk to the field to pick some potatoes for dinner. When she left the house, her daughters, Nellie and Mary, were sitting in the front of house, one of them on a swing and the other in a chair. Her eldest child, John, who was about thirty-five years old, was in the barn. When Bridget returned a short time later, she came back to a very different scene than the peaceful one she had so recently left.

Bridget found her beloved daughter Mary lying facedown on the steps of her house. She turned her over and noticed that Mary had blood running from her mouth and nose. Bridget screamed and started to look for her youngest daughter, Nellie.

She was shocked as she walked through the lower floor of the house. Bloody fingerprints on the doorways, blood smears on the walls and bloodstains on the carpet told a horrific tale. Bridget was becoming more frantic as she wandered from room to room with no sign of her youngest daughter. She rushed from the house to the barn, screaming Nellie's name.

When she reached the basement in the barn, she beheld another horrendous sight. Nellie was staggering around the room, blood coming

from her swollen nose and mouth. Bridget also noticed a green stain down the front of Nellie's dress.

But Nellie was alive and conscious and able to tell her rescuer the unbelievable story. It was her own brother John who had forced her to drink Paris green from a cup. This chemical was found on most farms and was used as a pesticide during this period. It was deadly to humans if consumed because it contained arsenic. According to Nellie's statement, John Hart had asked her to go out to the barn with him to assist with some task. When they reached the barn, John grabbed Nellie, forced her to drink green liquid from a cup and then shoved a gag into her mouth. She heard him leave the barn and then heard several gunshots; it was during this time that police surmised the killing of Mary took place. He shot Mary and then forced her to drink the Paris green. The blood stains found in the house indicate that Mary had gone inside and wandered through the rooms, perhaps looking for some help. Finding no one, she returned outside and fell by the front steps of her home. It was obvious from her disheveled clothing and the blood found that Mary struggled with her attacker.

After John finished with Mary, he returned to the barn only to discover that Nellie was not yet dead. He then shot her once in the chest. One would not even want to imagine Nellie's fear when she heard John's footsteps as he returned to the barn.

Dr. W. Helm was called to do what he could for poor Nellie. While the doctor was caring for Nellie, her sister, Mary, was lifted onto a board and finally brought into the house. Three hours had passed since the attack. Mary was left in the front yard covered with a sheet under a lilac bush while word spread, and her neighbors came to stare.

It was only after they lifted her that the story turned more brutal. While they were shifting the board to make it through the doorway, something rolled off the board and hit the floor. It was a cartridge from a .32-caliber gun. Mary's body was examined, and a gunshot wound was found in her neck. The gun was held so close to her that the flesh was burnt, and there was a hole burned in her dress. It was determined through autopsy that Mary had been forced to drink the Paris green and then shot four times at close range.

It was not until several hours later, when her brother William was helping Nellie change from her dress into her nightgown, that it was discovered that Nellie had also been shot.

By midnight, the doctor broke the news to Bridget that her youngest child would not recover. The Paris green she had been forced to drink had caused extensive damage to Nellie's mouth and throat.

John Hart's doctor was summoned and questioned by the police. Dr. Miller stated that he had treated Hart for physical problems but not for any mental problems.

The police also questioned the other family members. A brother, William, gave testimony to the relationship between the girls and John. He stated they quarreled "an awful lot." He explained that these arguments were because John wanted the family to buy out his portion of the farm. His family refused. They wanted John to stay and help them make the farm a success. It would take all of their combined effort to make the farm work. William went on to say that John had an ugly, irritable disposition and seemed to especially hate the eldest sister, Mary.

Coroner Agesen was called to begin the inquest into Mary's death. Her uncle, P. Hart, identified the twenty-six-year-old girl's body. The uncle also told the coroner that John, Mary's brother, had been ill lately and acted insane.

The search for John Hart began. A posse was formed, and people began to search all of the towns in the area. Hart was seen riding off with one of the horses from the barn. The search spread to Rockford. Around 9:00 p.m., Hart was spotted going into Henry Sparring's Barber Shop on Kishwaukee Street in town. As the police approached him, John remained calm and slowly took a bottle from his pocket. He raised the bottle to his lips and took a long drink. Later, the contents of the bottle were found to be laudanum.

Nellie fought for her life, spending hours in agony, but she passed away around two o'clock in the afternoon the day after the shooting. She was only twenty-three years old.

The family's troubles had started years earlier. John was considered the black sheep of the family. He had left twelve years before, and the scandal was that he ran off to Chicago with a married black woman. George Lewis and his wife lived in Pecatonica, and it was Mrs. Lewis whom John ran away with, causing the breakup of that family's home. John and Mrs. Lewis allegedly lived together in Chicago before he deserted her and left for California. John roamed around the South and West while working a variety of jobs. He worked on the railroad in Colorado and Arkansas and traveled back and forth to Chicago several times.

The father of the family, John Hart, died two years before the shooting. He committed suicide by the drinking the same poison that killed his daughters, Paris green. It took a while for the family to find young John to notify him of his father's death. He returned to the family farm about fourteen months before the murders. It was upon his return that he started to quarrel with the family about buying him out for his share of the estate worth around $50,000.

After being arrested for the attack on his sisters, John Hart was put into the jail in Rockford. A doctor treated him for the laudanum he drank. The opiate did not really threaten Hart's life since he had ingested such a small amount. There was some chaos outside the jail on the first night of Hart's incarceration. There was a band of men determined to string Hart up without a trial. But cooler heads prevailed, and the men decided to let justice run its course.

The Hart family was both well known and well respected. The girls were described as lovely and tall. They were always well dressed when they attended church services at St. Mary's Catholic Church.

The newspaper also described how surreal the experience felt to the family. The sun continued to shine, the cows were in the field and all of nature continued on as if this terrible tragedy had never taken place. But the brothers left behind were in a daze, and their mother's sobs were never ending.

Mary and Nellie's funerals were held together at St. Mary's Church on Rockford's west side. The crowd was huge; some estimates put it as high as two thousand people attending. The local newspapers stated, "The bright sunlight was eclipsed by the dark shadows of grief that spread over our city as the long funeral cortege, consisting of two somber-robed hearses and nearly one hundred carriages containing sympathetic mourners wended their melancholy way through Rockford's streets on route to the Catholic Cemetery." People lined the streets all the way to the cemetery, not from curiosity but to show their support for the family going through this unbelievable tragedy.

When the crowd was passing the jail, some looked up and saw John Hart staring down at them. This enraged them, and a portion of the crowd went running to the jail in an attempt to bring Hart outside to lynch him. The police took the threat seriously and fell out in full force. They were able to quiet the crowd and convince them to continue on to the cemetery.

It was only a few days after the murders that John Hart started to talk to the press. He seemed almost compelled to try to convince reporters and others of his innocence. The story John first told to the reporters claimed that he was innocent and that it was the other five Hart brothers who killed the sisters and tried to poison him as well. Their motive was greed spurred on by the vast estate that their father left to the family.

Shortly after his arrest, Hart made his first appearance in court. People who witnessed him during the proceedings describe him as cold, calculating and showing no signs of remorse for this "heinous crime." He again placed all the blame for his family's woes squarely on to his brothers. "Hart seems to possess

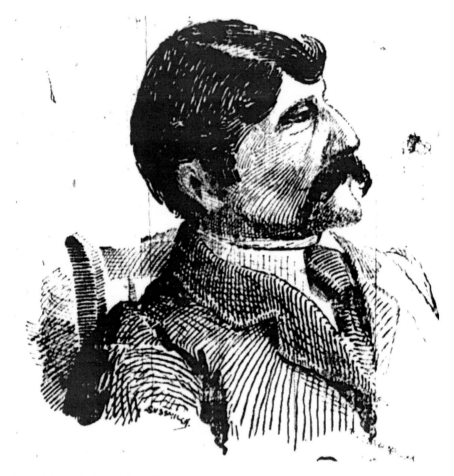

An artist's rendering of John Hart, who murdered his sisters in 1893. *From* Rockford Daily Register.

a bitter hatred against the living and dead members of Hart family except for his father and mother and the energy used in cursing them was intense."

In mid-December, John continued his insane behavior, which included frothing at the mouth and growling while refusing to eat. Hart was put in shackles and moved to a smaller, and thought to be safer, cell. On December 16, while he was awaiting trial, John Hart tried to commit suicide by slashing his own throat with a piece of glass from the window. The newspapers said the only shame was that he not successful. That act, had it been successful, would save the county the cost of a trial.

The trial began on Monday, January 22, 1894, and lasted fourteen days. The verdict of guilty was issued on Monday, February 5. The trial was quite

a spectacle. When the doors were opened on the first day, so many people surged forward that they ripped the wooden doors off their hinges. Estimates in the newspapers said that the crowd numbered eight hundred souls inside and out.

Attorneys Fisher and Garver were the defense attorneys, and they did all in their power to save John Hart from the gallows. State's Attorney Frost was the prosecutor, and he was assisted by his partner, Robert G. McEvoy. There were eighty witnesses called, with fifty-nine by the state and nineteen by the defense.

Hart's defense strategy was that he was ill, suffering from malaria and some sort of mental anguish. Just for good measure, he also testified that his sisters conspired against him and he suspected they had also tried to poison him.

The girls, of course, were not there to defend themselves against this charge. But the town's people were sickened by this display. Quite a few did not return to the courtroom. Nellie's deathbed testimony was allowed into evidence, and many called it "the death blow" for Hart.

Then Hart turned on the rest of the family. According to John, all of his siblings had conspired first against his father, killing him and making it look like a suicide. Then, when John came home to collect his rightful part of the inheritance, they decided to get rid of him as well. He proclaimed his innocence to all who would listen, and for good measure, John claimed that a buzzing in his head had told him to kill both of his sisters.

The newspapers all raved about State's Attorney Frost's cross-examination of the defendant. They commented on how easily Hart could be mixed up and that this fine attorney showed every claim for defense to be completely made up in order to allow Hart to get away with murder.

Frost was able to also undermine the testimony of a very "learned" doctor who claimed that even if John Hart was the cause of his sisters' deaths, he had mental issues probably brought on by the syphilis that John suffered from. It was this disease that caused him to commit such a heinous crime.

Attorney Frost brought up all the points that showed that Hart had tried to escape his fate. He ran away after committing the crime, used an assumed name, claimed insanity from syphilis and malaria and claimed he had bought a gun to protect himself from highway robbers but at the same time claimed never to own a gun. Hart also claimed to be a laudanum addict but also stated he never took the medicine. He apparently forgot the small bottle of laudanum that was found on him at the time of his arrest.

The jury was out less than an hour before coming back with the guilty verdict. The paper described it: "A whole lifetime was crowded into that moment of suspense, and the next instant he heard the stern words

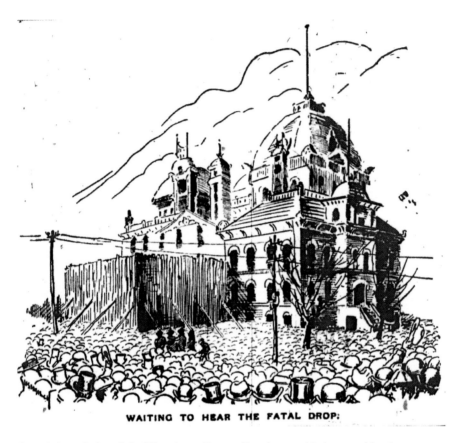

WAITING TO HEAR THE FATAL DROP.

An artist's rendering of the Winnebago County Courthouse with the crowd for the execution of John Hart in 1894. *From* Rockford Daily Register.

that would send him from this world forever and end a life that has scattered bitter sorrow and dark despair in its pathway."

Before the execution, a scaffold was built in the jail yard, and a stockade was built around it. The day before the execution, people came from all over to see the scaffold. John Hart could see the crowds through the bars in his cell. He talked bitterly about how sickening the people were who came with their morbid curiosity to view the instrument that would shepherd him to his death.

Seventy-five men were invited to watch the execution, but hundreds more pushed at the walls from the outside. Police officers were called to move the people back because the sheer mass of humanity threatened to knock down the stockade.

MURDER

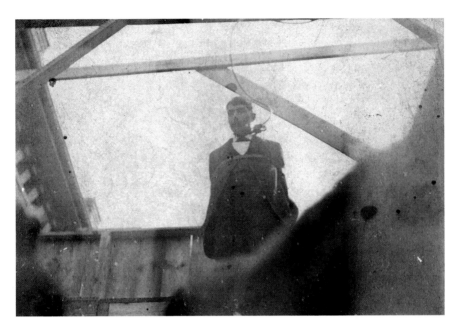

John Hart on the gallows in 1894. *From Midway Village Museum, Rockford, Illinois.*

At 11:00 a.m., the south door to the jail opened, and John Hart walked the last few steps to where the executioner and the noose waited for him. Hart was dressed in a new suit that his brother William had brought for him the night before. The priest from St. Mary's administered the last prayer, and then Sheriff Burbank led Hart to the trapdoor and offered him a chair. He refused, preferring to stand. The sheriff then asked Hart if he had any last words. "Upon the advice of my spiritual advisor, I have nothing to say."

The noose was placed around his neck, straps were tied to his arms and legs and then his head was covered with a white shroud. "There was an instant's pause, awful in its intensity. Then there was a dull grating sound, the death trap fell at 11:04 with a loud noise and the body of the murderer shot downward."

The rope cut into Hart's neck and turned the white shroud crimson with his blood. Thirteen minutes after the trapdoor was sprung, John Hart's heart stopped beating. After his body was taken down and the shroud removed, it was found that the rope had nearly decapitated Hart.

Those outside the stockade knew immediately when the trapdoor was sprung. It was heard from over a block away. As further notification, there was a man at the top of the courthouse who signaled when the deed was done.

Undertaker Bradley cut down the body and took it to his undertaker rooms to prepare it for burial. Much was said and written about John Hart after his execution. People were astonished that someone so well read and so well spoken could commit such a heinous murder.

He was young, tall, good-looking and very intelligent. This was not what people thought of when they spoke of criminals. No one doubted that he had committed the crime, but the debate was all about the motive. It seemed inconceivable to everyone that Hart would commit such a crime and would possibly have gone on to kill more of his family, all for the inheritance left by his father.

3
CRIMES OF A MONSTER

Everyone who was acquainted with Katherine Blake French knew she struggled with her marriage. The local newspapers of the day all stated she led a life of sorrow.

Kate French was twenty-six years old in July 1896. She was born right here in Rockford on June 11, 1870. She lived her entire life here, attending public school and graduating with honors.

Kate was well known throughout the city, especially since she married James French in May 1890. They opened up a little confectionery shop on the corner of Green and South Main Streets. It was there that their marriage turned bad. James didn't show much interest in the store, and it fell to Kate to do most of the work. James would sometimes watch his wife as she greeted customers. He seemed especially interested in the way she spoke to the men who visited the store to purchase cigars. James would often scold her and even strike her if she did not return to their rooms in the back of the shop when he ordered her to.

Kate's family was all too aware of the situation, and they tried to help. They tried to reason with James and tell him that his worries were unfounded. They also tried to convince Kate to leave James, but their arguments fell on deaf ears.

The couple occasionally separated as James's violence grew worse. But every time she left, Kate would forgive him and return. This continued until February 1896, when Kate finally realized there was to be no happy ending for her with French. On February 29, James

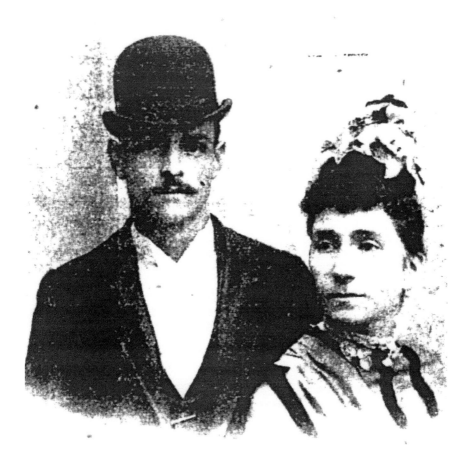

An early photograph of James and Katherine French. *From* Rockford Daily Republic.

attempted to kill her with a one-foot-long bladed dagger. Kate left James for good and moved in with her mother, Ellen Blake, at 519 Cedar Street.

Unfortunately, that was not the end of the violence between the Frenches. According to the newspaper, James made Kate's life a "living hell." James French stalked Kate. He would wait for her and taunt her with death threats. Kate found employment at the Nelson Knitting Factory not far from her mother's house and was supporting herself and her two-year-old daughter, Loretta. James waited for her after work and would tell Kate that she better work hard so that she would have enough money to pay for her coffin.

In the weeks before the attack, he would pass numerous times in front of the Blake house, taunting and threatening to wipe out the entire family. He was hauled in front of Magistrate Morrison, who gave him a fright that seemed to deter him, but it did not last for very long.

Kate French left her mother's house on Cedar Street at around 9:00 a.m. on July 20, 1896. She had not left her mother's house for over three days because of her fear of her husband. Only the need of her invalid friend could make her venture from the safety of her mother's house.

James had been standing outside for those three day, staring at her house and hoping to see her. Kate's house was right across from the Palmer Churn house, and workers would later state that they saw James walking by the house at all hours of the day and night, pacing around the house, just waiting for a glimpse of Kate.

On that Sunday morning, he asked a little girl if she had seen Kate. The little child could not have known what James French's motives were. The girl told James that Kate had gone to assist Ms. Callendar. James knew that this woman was a friend of the family and that Kate would go to help her. He even knew the path she would take to get there.

So James formed his plan and walked to Haskell Park to wait for her return. Kate finished helping her sick friend and started for the safety of her mother's house. She did not know that French was waiting for her in the park. James saw her walking down Cherry Street and followed her.

Kate didn't notice him at first. She must have been relieved to see a family friend there at the corner of North and Winnebago Streets. Kate stopped for a minute to speak with her friend Mrs. Fitzpatrick. She had no way of knowing that she only had a few minutes to live. It was while she was visiting with her friend that she first noticed James. It was 1:45 p.m.

Kate mentioned her husband to her friend, saying, "Here comes my husband, I am afraid he will hurt me." Her friend reassured her. "Never mind, he won't hurt you." James approached the women, called Kate a foul name and said he would shoot her. He then fired a shot right into her chest. Kate's friend Mrs. Fitzpatrick fainted from shock and fell to the street.

Kate ran across the street screaming for help. She approached the door of the Gorham residence on North Winnebago Street. She ran to the south side of the house, where the door led into the library. As she attempted to open the door, James caught Kate. He pulled her down and shot her. She struggled to her feet and opened the door. James fired at her again before Kate escaped into the house and ran screaming into the music room, located on the north side of the house. It was here that this

horrendous life and death struggle ended. James caught Kate again and fired more shots into her.

Kate's screams of "He's killing me!" and the gunshots on this sunny Sunday afternoon brought out the neighbors, who rushed to Kate's assistance. Several men—including Al Barker, Marcus Norton, J.C. Welch, William Andrews and W.T. Norton—ran to help Kate.

Barker was the first inside, and as he rushed forward, James aimed his deadly revolver at the brave man. Barker moved to the side just at the right time and narrowly missed being shot himself. He turned and ran out of the house. W.T. Norton found a gun on the ground outside and fired at French but missed him. When Norton's gun misfired, he also left the house.

James finally released Kate. She dropped to the couch and then fell to the floor. She struggled to hold on to her life for fifteen agonizing minutes.

"Every room in the downstairs portion of the house showed the crimson traces," witnesses would later report. Bullet marks in the woodwork and walls bore silent witness of the tragedy that had occurred.

James exited the house through the front door with guns waving to scare any who might have been brave enough to approach him. The shouting and running attracted more and more people until at least one hundred people pursued James as he ran up Winnebago Street to Locust Street, down to Church Street and then over to North Main Street. He was attempting to reach the river, where he could make good his escape.

James made it to the river but got no further because officers were right behind him. He attempted to steal a boat but discovered it was chained. The officers caught up to him, and James realized he was cornered. He turned the gun on himself, shot himself in the jaw and then jumped into the river.

Apparently, James was better at shooting others because his wound was not serious. Doctors examined James when the officers brought him to land. The crowd worked itself into a frenzy during the chase, so the officers quickly moved James into the police wagon. The action saved French from being dragged out of the river and lynched on the shore.

Kate's body was taken by wagon to the Bradley Undertaking House on South Main Street. A large crowd had gathered, and they all followed the wagon silently as it made its way through the streets. Dr. Moyer and Mayor Brown met the body. They were both horrified when they looked at the once attractive face. It was an "unrecognizable mass of powder burns and scarlet wounds." Both sides of Kate's face were ravaged by bullet holes under her eyes.

Kate received four shots to her head, two shots to her chest and one shot to her back. The revolver was held so close to her as it was fired that all

of the wounds had gunpowder on them, and the one to her chest actually caused the waist of her dress to catch fire.

Ellen Blake, Kate's mother, was distraught over her daughter's death. Blake lost her husband a few years before when he took a chill from falling into the Rock River. Shortly after the death of her husband, one of her sons had been killed. Kate's murder was just too much for the poor woman to bear.

Kate's funeral was held in her mother's home on Cedar Street. After the funeral, mourners made their way to the St. James Cemetery. Kate was so well loved that her funeral procession was one of the longest in Rockford's history up to that time. She was known and respected in the city, and many spoke of her life of sorrow because of the unwarranted jealousy of her husband, James.

James rented a room from a friend, Anton Ward, at 328 South Court Street after he and Kate separated. The Wards knew James to be a quiet, almost timid young man. James was thirty-two years old in 1896 and had lived in Rockford for about seven years prior to the murder. He came to America from Calabria, a town in south Italy where he was born on April 15, 1866. He moved to the United States in 1884 when he was eighteen years old. James worked as a tailor in Canada and Utica, New York, before moving to Rockford.

No one seemed to know James very well. All anyone could say about him was that French was not his real last name. In fact, it was later determined that his real name was Gamino Frencel. Since the separation, he had worked for a tailor named Skinner. Skinner discharged James the week prior to the murder because his drinking started to affect his work.

But if James was expecting sympathy from his countrymen, he would be disappointed. The Italian community was incensed by the act of depravity and supported the requested sentence of hanging. Chief Bargren met with some of the leaders of the Italian community, who expressed regret that it was a fellow Italian who committed one of "the foulest crimes in the history of this county."

While in jail, James seemed almost happy for a while. Several hundred people were allowed "in to visit" with James. In those days, this term meant the townspeople were allowed to come into the jail and look at French. French gave interviews and seemed quite content to be there. When told that his wife had died, he said he was glad. He also mentioned that there were other people that he would have killed if given the chance.

Some of James's former co-workers stated that prior to his family troubles, James had been friendly and a hard worker. But as his troubles

with Kate and her family grew, he increased his drinking and became so angry that it changed him completely.

When it was time to appear in court, James was no longer the happy-go-lucky man who was glad his wife was dead. He wore dark clothes and seemed "melancholy." The sheriff said he was the perfect prisoner and did not socialize with the other prisoners but mostly kept to himself.

In October, James pleaded not guilty, and his attorney asked for a change of venue. This request was not a surprise to anyone. They knew how popular Kate was in town. The change of venue request was later denied.

James was not brought to trial until May 1897 because of a change of attorneys and other causes. The plea was not guilty by reason of insanity. The defense attorneys wanted to have James's family history on record. Several family members, including his mother, had mental issues that had caused them to commit suicide. On the opening day of the trial, the courtroom was crowded, and the crowds grew as the trial progressed.

State's Attorney Frost represented the people. Attorney Pierce took the case after the original defense lawyer resigned and was assisted by Attorney Ferguson. Testimony got quite heated at times between the two attorneys.

On the final day of the trial, the crowd had grown so big that people lined the hallways and spilled onto the courthouse lawn to await the verdict.

James French was found guilty of the murder of Katherine French and was sentenced to hang. James showed no signs of emotion at all. In the eight weeks prior to the trial, he had lost over forty pounds and now weighed only about one hundred pounds. He was pale and stoop shouldered. Two weeks before the hanging, he stopped eating and would only accept water and whiskey. He still joked with his jailers and even played card games with Sheriff Oliver, but still, his hunger strike continued.

When James spoke of his execution, he referred to it as his "holiday." He had no regrets, but his last wish was to see his little daughter. This wish was granted on June 7. It was a gut-wrenching affair for all who witnessed it. Kate's sister brought the little girl, Loretta, now three years old, to the jail for the visit. The little girl chatted with her father, telling him that she had visited her momma's grave to place flowers there. James broke down completely when the little girl left, showing emotions for the first time throughout the whole ordeal.

Sheriff Oliver hired M.F. Malone, an expert from Chicago, to build the scaffold that would be used in the execution. The sheriff had received over one thousand requests for tickets to the executions, mostly from women. He denied all of them and only issued tickets to reporters, clergy and police officials, including sheriffs from neighboring towns.

James did not sleep the night before his execution. He spent time with Father Burke of Chicago and Father Solan of St. Mary's Church. During his final moments, when asked, he refused to say that he did the deed or that he was sorry for it.

James French was hanged at 11:20 a.m. on Friday, June 11, 1897, at the Winnebago County jail yard. Over two hundred people witnessed the hanging. A large crowd was also gathered outside the stockade hours before the hanging.

When Malone placed the black bag over James's face, he fainted. The trapdoor was pulled, "and at that moment James French was plunged into eternity. His fall was accompanied by a sickening thud and the crowd shuddered. There were a few convulsive movements and it was all over." At 11:35 a.m., his body was cut down and released to the priests from St. Mary's for the funeral and burial.

Kate French's sister received custody of Loretta and raised her in Ellen Blake's home with the help of Kate's brothers. One could only hope that watching her small grandchild grow gave Ellen Blake some comfort after the loss of her beloved daughter.

4
WINGS OF MADNESS

Thomas Ennett was born on the Isle of Man on August 12, 1831. He learned his trade as a mason and contractor on the great water wheel of Laxey on the Isle of Man. This water wheel, which is used for running the Manx mines, was the greatest work of its kind in the world for many years and was the second-largest wheel in existence in 1908. Thomas arrived in Rockford on May 8, 1853. There, he met Ellen Milner. Ellen was born in Sawley, Yorkshire, England, on October 6, 1833. She traveled to America in 1849 and settled in Rockford. The couple married in 1857. Ellen was twenty-four years old that year.

Thomas continued his trade as a mason when he arrived in Rockford and eventually built his own business, Ennett and Sons. He assisted with the original Rockford Police building, St. Mary's Catholic Church, St. James Catholic Church, the original First Presbyterian Church and many businesses throughout the city. He was well known and very respected for the fine workmanship he brought to the building trade.

Thomas and Ellen had ten children together. Thomas constructed a home for them on North Second Street, a beautiful brick building that is still standing. Ellen died on January 28, 1897, in her home. Unfortunately, she had been an invalid for many years before her passing. Ellen gave birth to all ten of her children and considered herself to be a blessed woman when they all lived to adulthood. Ellen and Thomas were proud of their extensive family. Thomas must have been relieved to have such a caring family, especially when the girls stepped in to help run the family

after Ellen started to have her "troubles." Ellen had mental issues and at times became so difficult that she had to be placed in an asylum in Joliet, a fact that tortured the family. But Ellen was really the lucky one because she passed away before the dark times came to her family. She never saw the destruction that was to come.

In 1898, the Ennett family was doing well. Ellen had passed away, but the family had pulled together. Eight out of the ten children still lived at home, and none of them had married yet. Neighbors and friends would describe the family as very close. In fact, one said that "they had never seen a family which seemed to live for one another than the Ennetts did." The family was so good at running things that Thomas took an extended vacation to the Isle of Man, returning on August 2, 1898.

August 16, 1898, was, by all accounts, a typical day in the Ennett household. At least that is how the day started; by the end of the day, nothing would ever be the same for the family. Thomas and Ellen's first child was George, who was born in 1861 in Rockford. When he became an adult, he was considered a talented mechanic. Folks around Rockford knew that if it moved or had moving parts, George Ennett was the man to take it to if it needed repairs. George was very active and enjoyed the outdoors, spending considerable time hunting and fishing.

Sometime around 1888, George had an accident. He was working on one of his father's many properties and took a bad fall, striking his head on the stonework that surrounded the yard. That injury changed George's personality. He didn't want to travel, hunt or fish anymore, preferring to stay at home. He also read a lot, especially history books. Neighbors noticed the difference in George and called him "peculiar." Not that anyone said anything to his family, least of all his father. Thomas Ennett was too highly respected in Rockford for that.

George seemed harmless enough; he never quarreled with anyone. He just didn't go out much and seemed to get depressed a lot. George was considered good and kind, except when he ran out of tobacco for the pipe he was constantly puffing on. Neighbors also noticed that his sister Anna had a way to get George out of his dark moods faster than anyone else in the family. It was obvious to everyone that she was his favorite.

Anna was the second born and was thirty-five years of age in 1898. She assumed the mother role after Ellen became ill and couldn't function anymore. Anna worked very hard to make sure the household operated smoothly, and she never complained.

During the morning of August 16, everyone had gone their separate ways to work on their daily jobs. The only thing different about that day was that George and his youngest sister, Nellie, spent the morning cleaning up the yard and the surrounding properties their father owned. There had been a storm the evening before, and there was debris in the yards. George was teasing Nellie because she was so slow at sweeping the sticks from the sidewalks.

The family had dinner together on that August day; back in 1898, the big meal was served at lunchtime. Thomas gave the children their jobs for the afternoon and went upstairs to his office. Joseph was at the firehouse; William was in Wisconsin on a hunting trip; and Samuel, John, Fred and Charles, all of whom worked at the Ennett and Sons Contractors with their father, went back to work. Mary was on the second floor of the house sewing, and Nellie and Anna were in the basement helping Mrs. Nord, the woman they hired to help with the laundry.

Thomas asked George to clean the cellar of one of the homes they owned. George nodded his assent and climbed the stairs to his room to change into his work clothes.

Nellie later said the women were working in the basement, washing and wringing out the clothes with their backs to the doorway. Nellie didn't even turn around when she heard George come down the stairs. The next thing she heard was a loud gunshot. She was so startled that she fell to the ground. She had just hit the ground when there was another shot. Nellie was sure she was hit but scrambled out the side door to the basement on her hands and knees. She stated she had never been so frightened.

She made it around to the front of the house, where she started screaming for her father. Thomas, hearing his daughter's screams, ran out into the street where Nellie told him that George had shot at her and Anna. Thomas headed back toward the house when he heard a third shot sound from the basement. By this time, neighbors were startled by the shots and ran to see what was happening. They would testify later that they saw gun smoke rising from the open basement windows and doors.

Thomas ran back into the house followed by his neighbors Dr. Sowie and Henry Posson. They ran into one of the rooms and were shocked to see George sitting in a chair, his head thrown back and the left side of his face completely gone. The neighbors stayed in the room, which was blotted with blood and brains on the walls and pictures. But Thomas ran frantically from the room up into the main portion of the house, calling Anna's name. He thought that she might have escaped the basement like her sister. He found his daughter Mary on

the second floor sitting at her sewing machine. She was shaking and obviously upset but otherwise unhurt. He ran through every room of the house and found no sign of Anna. Then, more slowly, Thomas returned to the basement washing room, where he stumbled on the body of his eldest daughter.

The damage to her was significant; George had leveled the shotgun to the back of her neck. The projectile exited through her mouth and tore away the whole lower part of her face. The neighbor had already found Anna and described the scene later to the police: "It was a pathetic sight to see her laying as she did by the side of the implements of her daily toil, her frame slight and bent from the burden of care that it had borne for so long, and her hands that had toiled so hard for her loved ones, now still in death."

Mrs. Nord, who had stood beside Anna wringing out the clothes, was obviously in shock. She had not registered anything and was still wringing out the wet clothing as if the last few minutes had never happened.

Henry Posson ran to alert the coroner and the police and to call Joseph home from the firehouse. Coroner Frank Marsh arrived at the scene and examined the bodies.

Coroner Marsh later determined that after Thomas told George to go clean the other cellar, he walked up the stairs to his room, loaded his shotgun and put extra shells into his shirt pocket. He then walked back down the stairs to where his sisters were working. George raised the barrel and shot Anna at such a close range that there was stippling around the wound. Next, he turned the gun toward Nellie, who had fallen to the floor, and aimed where he thought she was standing and fired again. The gun discharged so much smoke that he didn't realize that she had not been hit.

George then went into an adjoining room and placed a chair in the center of the room. He sat down and took off his shoe, pulled off his sock, placed the gun between his knees and laid the left side of his head down on the muzzle. He used his big toe to pull the trigger.

The papers were allowed into the crime scenes back then, and the reporter who covered this story wrote, "George sent the spirit of his sister Anna into eternity and there seated in his chair with his head thrown back was George Ennett, a pool of blood on the floor beside him and a shotgun between his knees."

The bodies of George and Anna were carried to an upstairs room, and the coroner and a family friend prepared them for burial. The bodies were in such awful condition that it took Coroner Marsh several hours to prepare them.

Coroner Marsh conducted an inquest around five o'clock that evening in the same room as the bodies. The jury questioned several witnesses and

carefully listened as Nellie lived through the horrendous events again as she told the tale. No one was surprised by the verdict: Anna was murdered by her brother George, who then turned the gun on himself in an act of suicide. "It must have been a streak of mental aberration that he inherited from his mother and intensified by his secluded life. What circumstances fanned the murderous passion into a flame no man can say," was the jury's final word on the tragedy.

The family held a double funeral in the home and brought both of the deceased to Cedar Bluff to rest near their mother and each other. This was a turning point for what had been, up to now, a blessed family. One might hope that the family was able to put this time of trouble behind them and went on to live happy lives. The family seemed to remain close, but though most of them found happiness, trouble seemed to stalk the others.

Thomas died in 1908 and left the family home to his son William, born in 1873. William worked at the Parson Lumber Company until 1917, when he abruptly sold the home, which had been in his family for over fifty years—the house his father had built with his own hands. William did not explain this action to the rest of his siblings. He simply told the family he was leaving and they would never see him again. He left Rockford for parts unknown. In 1947, thirty years after his bizarre disappearance, the family filed a petition to have him declared dead.

Mary, born in 1865, lived until the age of sixty-five and died on November 11, 1930. She never married and kept house for her brothers Charles and Samuel.

Charles, born in 1867, lived until 1944, when he was seventy-seven years old. He seemed to live a happy life after his retirement. He spent most of his days fishing. In fact, he was returning from a fishing trip on the Rock River and pushing his boat and trailer up the street toward home when he suffered a heart attack and died in front of 200 Market Street.

Joseph was born on August 12, 1869. He worked for a time with his father as a stonemason and also as a fireman. He married Margaret Higgins in 1899. They had three children, Beatrice, Frances and Thomas. His name is in the papers quite a lot, as he expanded his father's business. Joseph moved to Long Beach, California, for health reasons in August 1920. He died there in 1921, and his brother Samuel brought him and his family home. Joseph was only fifty-one years old.

Samuel lived until eighty-three years of age and was considered very healthy for his age. In January 1947, he died when he fell down the back stairs in his home on 630 North Court Street.

Another son, John, also known as Jack, born in 1871, was mentioned in the newspaper many times for fighting and drunkenness. When he would drink he would lose control, yelling, marching around downtown and going on rampages. He even shot a neighbor's horse during one of his "fits." He died in 1951 at the age of eighty. He was buried away from the rest of the family in Willwood Burial Park.

Nellie, born in 1876, the other attempted victim of that brutal August day, made a good life for herself. She married Henry Perkins, and when she passed away in May 1959, she left an estate worth $70,000.

Fred Ennett, born in 1877, was not so fortunate. After a series of failed business ventures, he killed himself in the barn of his home on Market Street on December 2, 1924. The family claimed that it was murder, and they had a good case for a while. Their main evidence was that Fred had been shot three times. He was shot two times in the body and once in the head. The bullet entered under his chin and exited his cheek. His funeral was held at his brother Samuel's house on Court Street.

The Ennett family's legacy does not only include death and murder, though. A few of the buildings that Thomas and his sons built are still standing today, a tribute to their quality and design.

5
INHUMAN MONSTER

Little Richard Tebbets lived in Rockford in the early 1900s. His life was not an easy one. His parents divorced, and his mother had to struggle to support her five children. She worked as a cook at a few of the local hotels, like the Chick House and the Jarvis Hotel.

But Richard—or Little Dick, as most people knew him—made the most of it. He was very tiny for his age of seven years, but because of his family circumstances, he was well known throughout the city. Dick started working as a newsboy when he was just four years old.

The newspaper was so proud of the little boy that it even did a story about him. It mentioned that he would use some of his hard-earned money to buy new clothes for himself. Dick would then wear them so proudly; he looked like a little king as he showed them off.

Dick was very popular with reporters and customers alike. He was known for being a hard worker. Dick would show up for work very early in the morning to get his newspapers and enthusiastically set out on his route. He always came back in the late afternoon for the second run. When he first started to sell the papers, he was so small that the bag would drag along the ground while he walked around yelling out headlines. People were impressed with the little boy's enthusiasm and his attitude. The men who knew him thought he was going to make a name for himself. In their opinion, Dick was going to be another Armour or Rockefeller.

On June 22, 1903, Dick was at the office bright and early to pick up the newspapers and start his day. The men in the newspaper office noticed when

he did not come back for the second round of the papers that afternoon. They were used to him returning early and sitting down to visit with them. Everyone enjoyed talking to the bright little boy.

When he did not return home that evening, his mother sent the other children to look for him. They searched all the places where Dick was known to go. Everyone knew something was wrong when he did not show up at the newspaper office the next morning. It was so unlike the little boy to miss work.

His family was frantically looking for him. Their greatest fear was that he might have fallen in the river. He was so small; they all knew that if he did fall into the water, he would be too weak to climb back out again.

The police became involved when he still had not returned by the first morning. Everyone was trying to find out where Dick was last seen. Some men who worked the railroad yards knew Dick and reported that they had seen him down by the tracks with a strange man. They noticed this man around for a few days prior to the disappearance. He was with another young boy, and they both had gone under the train viaduct. The men then heard the young boy calling for help. The boy broke free from the man and ran to the men to tell them what the strange man had requested. The railroad men chased the stranger until they lost him. This incident took place the day before Dick went missing.

In 1903, the city had a large racing park called Rockford Driving Park. It was used for horse races in the beginning; then, as transportation advanced, it was also used for motorcycle and car races. The park was located on the west side of the river, close to the present-day Welsh School.

On June 30, men were working on the Milwaukee Railroad by the Driving Park entrance located near the intersection of Adolphson Road and Huffman Boulevard. It was around 2:00 p.m., and the section foreman, Christian Hayer, was talking to a farmer whose field was by the train tracks when he noticed something in the grass. He walked closer and was at first confused by what he saw. It took a moment for his brain to comprehend what he was actually seeing. He quickly backed away.

The mysterious disappearance of the little boy had been solved in the most horrible way. Chief Bargren and Coroner Frank Marsh arrived on the scene about the same time. The two seasoned professionals were sickened by the sight that lay before them.

The tiny body of Dick Tebbets was lying on his back and was horribly mutilated. He was naked except for his shirt, which was bunched up around his chest. His pants were a few feet away from the body, and

his newspaper bag lay on the other side. His suspenders were wrapped around one of his wrists.

Several clues were evident at the scene. There were unsold papers that were dated June 22, the day Dick had last been seen. There were pennies and nickels that must have been from sales scattered on the ground, and there was a small bag of candy inside the newspaper bag. Chief Bargen gently removed the gag from the boy's mouth, and several of his teeth came with it. The child had been beaten and cut in a manner that neither the chief nor coroner had ever seen.

Coroner Marsh tenderly wrapped the tiny body in a sheet and transported it to his undertaking rooms on South First Street to prepare it for an inquest. E.S. Tebbets, the boy's uncle, identified the body to spare both of the parents from seeing the awful condition of their son.

Dr. Tuite, who knew Dick, also identified him. Dr. Tuite also conducted the examination of the boy's body. He declared that the body had been mutilated by a very sharp knife. Dr. Tuite also testified that the state of decomposition led him to believe that Dick had been killed on June 22, eight days prior to being found.

Dick's father, A.L. Tebbets, also testified about the separation between the parents, years previously. He did not live with the rest of the family but stayed in a boardinghouse at 718 Elm Street. He told the jury the details of the search the family had made all through Rockford, Belvidere and Marengo.

The mother spoke next. She testified that she did not see Dick on June 22 because he was sleeping when she left for work, but her daughter had seen the little boy around seven o'clock in the morning selling papers on the street. The devastated mother told the jury of the last time she had seen the child. He was speeding through his prayers the night before his disappearance, and she chastised him. "All wight, mama," he said before starting them over. These words were the last he ever spoke to her. The mother's grief was almost too much for spectators to bear.

Because of the state of the body, it couldn't be kept any longer, and his remains were buried the same evening. His family and a few friends were able to attend the funeral at Greenwood Cemetery.

A few days after Dick's body was discovered, a little boy in Beloit reported to police that he had escaped from a man who matched the description of the man who was chased away by the railroad men.

In August, Rockford headlines blared the news that two more boys had been found murdered, their bodies left in the same condition as Dick's. The latest one was in Detroit, Michigan. The little boy had been identified as

Alphonse Welmes, who left his home to go play with a cousin. The four-year-old's body was found horribly mutilated.

Detroit police were able to move quickly and arrested Charles Price, though his real name was Emil Waltz. The Detroit police sent a picture of Waltz to Chief Bargen, who showed it to the men who had claimed to see Dick with a strange man. Emil Waltz was forty years old. He was six feet tall and 190 pounds and had a medium build, sandy hair and blue eyes. He had scars from gunshots above both knees and on the left side of his chest.

Waltz had been arrested in Michigan before for grand larceny and served time in Ohio and Michigan prisons, including a charge for manslaughter. Waltz traveled to Toledo, where he was arrested and returned to Detroit. While Waltz claimed to be innocent of the murders, he did verify that he was in Rockford during the time Dick was murdered.

Police checked into Waltz's story and found out that he was in Rockford using the alias Ole Walters. He stayed at the home of John Lindstrom and worked at the Forest City Furniture Company between June 14 and June 20. Lindstrom reported to police that Walters left his house without paying his rent on June 22, the same day that Dick was killed.

Waltz was found guilty of the murder of Alphonse Welmes after a six-week trial and sentenced to life in prison. He was sent to the penitentiary in Marquette, Michigan. Waltz was not intimidated by incarceration and would constantly break the rules and challenge authority. His anger, constant taunting and physical attacks kept the other prisoners and the guards on edge. Once, Waltz was somehow able to purchase liquor and attacked a prisoner with a large knife. Authorities were unable to discover where he acquired the knife; they did, however, find that he had bought the liquor from one of the guards. The sheriff was suspended for this charge.

On July 23, 1905, Waltz was again in trouble for breaking a rule. When he was taken to the office to be reprimanded, he defied the guards and then pulled a large knife from under his shirt and threatened them with it. One of the guards, Deputy Catlin, grabbed a nearby wooden chair and was going to use it against Waltz. Waltz lunged toward the guard, but instead of attacking him with the knife, he belted out a wild yell and then plunged the knife into his own side. The man suspected in Dick's death died without confessing to his murder.

The arrest of the child killer gave Rockford some relief, even though he was never charged with the death of Little Dick. His death brought many unanswered questions—the main one was what compelled this man to murder and mutilate little children? Authorities never got their questions

answered, though specialists, called alienists during that time, were able to interview Waltz and answer a few. The terms "cannibal" and "pedophile" are, unfortunately, more familiar to us now than they were at the turn of the century. But that does not mean that the crimes are any better understood now than they were then.

The death of Little Dick Tebbets was felt by every citizen in Rockford. This little boy—so well known and remembered for his hard work, enthusiasm and his trusting nature—represented all of the children in Rockford. The fact that Little Dick could be taken and murdered meant that any child could. The fear that held every parent in its grip had never been experienced at this level prior to this little child's death. The fact that a total stranger could hurt one so small was inconceivable. Unfortunately, it would not be the last time that fear was felt in this city.

6
THE FURY OF A DEMON

Mary McIntosh's maiden name was Mary Grieve, and she was born in Scotland. She married Thomas Laing in 1850 in Roxbroughshire, Scotland. They came with Laing's family to America and settled in Ohio, where Thomas died in 1851. Mary then married Anthony McIntosh in Cleveland, Ohio, and they lived there for several years before moving to Rockford. They had no children, and when Anthony died, Mary was left all alone.

Mary McIntosh was murdered in her own home at 1339 West State Street on the corner of West State Street and Forest Avenue on Thursday, January 20, 1910. Her body was horribly mutilated and found in her living room.

The newspapers of the day stated that, according to those who knew her, "Mrs. McIntosh spent days, weeks, months and even years in a big arm chair and even slept in it." She was what is known today as a hoarder. The newspapers described all the clutter that filled the house, stating that the "furniture was piled high with articles that she had been hoarding for fifteen years."

For years, friends and neighbors tried to talk Mary into leaving her squalid home. She always refused and talked about her faith that she was going to get better and get her strength back. The friends would stop in regularly to visit.

They also told the police that Mary came from a fine family from Scotland. Mary's mind had become a little unbalanced after she ran into some trouble with her finances in the 1890s. No one knew her exact age but would put her at least eighty years old.

Mary lived in Rockford for at least fifty years. Her husband, Anthony, built their house on West State Street. Anthony worked at the Emerson plant for years but was also known for his carpentry skills. He built a little one-story cottage but then added the two-story wing. He passed away twenty-five years prior to Mary's murder. By all accounts, Anthony left his wife very comfortably settled financially.

Then in 1890, Mary invested with a real estate man in whom she had complete faith. Unfortunately, her faith in him was a mistake, and though not left penniless by the bad investment, she lost quite a lot of money. This appeared to change Mary, and her family noticed she became bitter. Uncharacteristically, she started to quarrel with her neighbors and their children.

Mary's milkman, Henry Branthauer, discovered her body on his daily visit at around 11:00 a.m. on the cold January day in 1910. Henry thought that Mrs. McIntosh had just passed away from a fall. Her body lay inside the front door with a pool of blood around her head. The milkman thought she might have hit her head when she fell. For some unknown reason, instead of calling the police, Branthauer called the McAllister Drugstore to report his find to the druggist there, Mr. McAllister, who told him to notify the police.

The police arrived and had to force the door open because Mary's body blocked it. Further questioning revealed that groceries had been delivered to the McIntosh home around 9:30 a.m. The delivery boy had actually entered the house through the back, set down the bag and left. He did notice blood on the snowy path that led to Forest Avenue. He followed the shoe prints all the way to the back of the property. These would later be identified as bloody footprints from the murderer.

The mailman, Fred Cronk, was the first to turn up any solid evidence. He was on his way back from a lunch break at his house at 201 South Central Avenue when he found an envelope containing two ten-dollar gold pieces close to Central Avenue. These were with other envelopes bearing Mary McIntosh's name. Other mail was found all the way to Independence Avenue, blocks away from Mary's house. Cronk turned these over to the police. He was very surprised to hear that Mary had been murdered.

The attack, the police surmised, had happened right where her body lay. They thought that she had opened the door to someone and would have been powerless to fend off an attack. The only motive that could be offered by the police was robbery. Mary was not known to have a lot of money in the house, but when the coroners were conducting the autopsy, they discovered a mark around Mary's waist that could have come from a money belt that she must have worn for years. This fact led them to believe that whoever had

made the attack on this poor defenseless woman must have had knowledge of the belt.

Mary's body told the tragic tale of the attack. She had a bruise on her forehead right above her right eye. This was the blow that, hopefully, rendered her unconscious. What came next is horrible enough that it helps to think that she was not conscious for it. It does not make it any easier to understand why someone would attack this defenseless woman who was in such a weakened state. The attacker slashed her throat not once but twice. The first slash was about five inches long, described by the paper as a "ragged cut that gaped widely." The second wound was deep and severed her windpipe, making it impossible for her to cry for help. There were three more cuts on the body, including the cut that disemboweled her. Coroner McAllister theorized that the cut on her abdomen was made while removing the belt that held her money and papers.

Another piece of evidence that this was not a random attack was the condition of the house. Even if a stranger had broken in, the mess in the rooms "would have turned him back, no matter what his previous idea had been," the police stated. Mary collected many items and stacked up clutter in every room of her house. It was obvious from the state of her home that she only used the room that was her living room. Bedrooms held beds, but everything was filled with clutter and "rubbish covered the floors."

Men who dealt with Mary for her finances stated they did not know of the money belt and that, as far as they knew, Mary kept her money in the bank. Neighbors told the police that Mary McIntosh was very afraid in her later years. She kept all the doors locked and windows shuttered. They said she spoke of her fear often.

Clinton St. Clair, who lived at 1330 Quarry Street, was arrested on January 21, 1910, for the murder of Mary McIntosh. St. Clair admitted he had committed the murder at one o'clock on Thursday morning and got thirty dollars (or seventy-two dollars, depending on the version) for his crime. St. Clair was around thirty years of age, had a short build and weighed about 225 pounds. He was described as "a man of less than ordinary intelligence."

There was a great amount of evidence that pointed to St. Clair. Police found clothing that was thought to have come from the McIntosh home inside St. Clair's house. There was blood on the coat he wore when he was arrested and bloody footprints left in the snow leading away from the house that matched his shoe size. They found scraps of clothing in a closet at his home that St. Clair thought he had burned. The final piece of evidence used against Clinton St. Clair was an envelope that was found on the ground

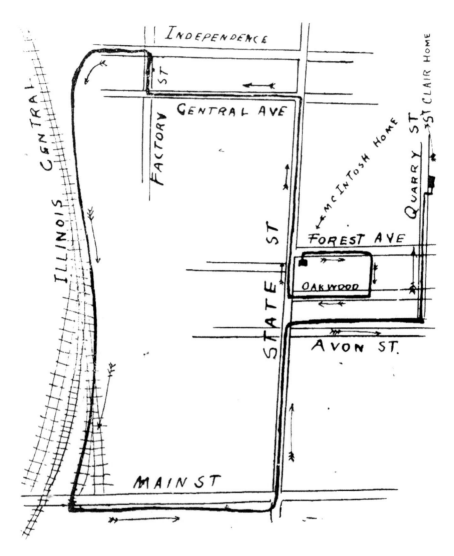

A hand-drawn map showing St. Clair's route home from the McIntosh home and locations for the recovered evidence. *From* Rockford Republic.

outside of the McIntosh home. It was mixed up in a stack of paperwork from inside the home. The envelope was from Clinton St. Clair's wife, Bertha, to Fred Conoway of Stillman Valley. It was a plea to inquire if Conoway had any work for her husband.

It was this envelope that would lead police straight to St. Clair. St. Clair's wife had given him the letter to mail on Wednesday night, and it

was found by Sergeant Reed in a stack of papers. The letter was in three pieces, but the police taped it back together to read it. The police took the letter to Fred Conoway to find out the identity of the Bertha and Clint mentioned in the letter.

By the time the officers arrived at the St. Clair house, everyone was in bed. The police woke them up and took Bertha and Clinton down to headquarters to be questioned. Other officers searched the house while the St. Clairs were being interviewed. It was during this search that the garments from the McIntosh house were found. All of the garments were covered in blood, including a white underskirt.

Mrs. St. Clair claimed that she and her husband had attended a friend's party on Wednesday evening and that she did not return home that night. Her husband left the party at 11:00 p.m.

According to St. Clair's statement, he had shown up at Mary's house around one o'clock in the morning. He rapped on the door and was admitted by Mrs. McIntosh. St. Clair demanded money from Mary, who claimed she didn't have any. St. Clair then knocked her over the head, used a pocketknife to cut her throat and then disemboweled her.

When asked why he would do such a horrible thing, he claimed, "I was out of a job and needed money and would kill to get some." This was not the first time that Clinton St. Clair had been questioned about his role in a death. Two years prior to the McIntosh murder, he was questioned about the death of Mrs. Lang, who was killed on the Burlington tracks near Chair Factory B. She had been "ground to pieces on the tracks when she was run over by a train." When questioned about Lang's death, St. Clair stated that they had both been very drunk and that he had passed out and had no idea what had happened to Lang. There was not enough evidence to prove his guilt, and the police had to let him go.

The most damning evidence was the knife that was found on him when he was searched. It was a double-edged dagger with a large blade. There was blood and hairs stuck in the blood on the blade. State's Attorney North and Chief Bargren complimented the good police work by Sergeant Read when he picked up the letter and all that followed.

Later, St. Clair's wife would try to explain his bursts of violence with a story of a bite from a mad dog. She said that the whole family thought he would eventually go mad. Mrs. St. Clair also said that her husband was a good, gentle man except when he would have his fits or when he was drinking.

St. Clair was described as a simple man. The sheriff stated that he grew agitated if questioned about the crime but was calm otherwise. He ate and

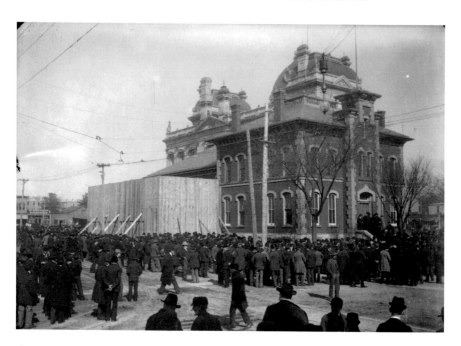

A photograph of the stockade built for the execution of Clinton St. Clair in 1910. *From Midway Village Museum, Rockford, Illinois.*

slept well during his incarceration. Neither St. Clair nor his wife seemed to understand the severity of the crime and the possibility of the death sentence. Their friends seemed to step around the topic when visiting Clinton in jail.

State's Attorney Harry B. North decided to ask for the death penalty due to the gruesome nature of the murder. B.A. Knight was chosen as the defense lawyer, and the presiding judge was Judge Frost. Clinton St. Clair was found guilty of the murder of Mary McIntosh and sentenced to "hang by the neck until dead."

At 8:28 a.m. on April 16, 1910, Sheriff Collier took Clinton to the yard of the jail, where the gallows waited. The sheriff asked Clinton if he had anything to say, and though Clinton's lips moved, no one heard any of his words. Father Whalen prayed with Clinton, and then his arms and legs were tied. As Sheriff Collier fastened the noose around Clinton's neck, the doomed man made eye contact with the witnesses in the front row. The shroud was lowered over his face. Sheriff Collier stepped over to the knob and pulled it. Clinton's massive weight fell the five feet and jerked to a stop. His neck broke, and death was instantaneous. His body was cut down ten minutes after the trap had fallen.

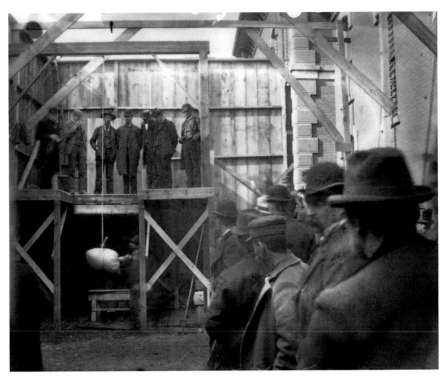

Above: A photograph showing the rehearsal of St. Clair's execution. *From Midway Village Museum, Rockford, Illinois.*

Right: A photograph of the noose used to execute Clinton St. Clair. *From Midway Village Museum, Rockford, Illinois.*

The man who had accompanied the scaffold from Chicago, Mr. Davis, had witnessed over fifty hangings. He stated that this was the most efficient hanging he had ever seen. The scaffolding was dismantled and loaded for delivery back to Chicago by 3:00 p.m. The crowd that actually witnessed the hanging was small compared to previous hangings, but there were still several thousand people crowded on the streets outside the stockade.

Clinton St. Clair's body was taken to St. Mary's Church for the funeral. Father Whalen accompanied St. Clair to the gallows and then to his burial. The priest was originally worried that there would be a crowd of morbid curiosity seekers, so they took a back way to St. Mary's Cemetery, but he didn't need to worry. There were only two mourners at the service: Fred St. Clair, a brother of Clinton's from Dixon, and John Pensinger of Freeport, who was a brother-in-law of Mrs. St Clair. Bertha was too distraught to even attend the funeral. The time between the death of Mary McIntosh and the execution of St. Clair was just a little under three months.

When officials gathered and liquidated all of Mary's assets, they found she was in a very good financial state. All of her fear and bitterness about people cheating her of her rightful money was in vain. Mary McIntosh shared with friends that she was very frightened to be alone, she kept the shutters closed on the house and she installed locks and chains on all the doors. Sadly, none of these precautions did her any good.

This story should end here, both victim and killer in their graves and justice served. There is, however, another article, dated May 14, 1910. Clinton was a model prisoner during his incarceration, but he did suffer from some stress. Men serving time at the Winnebago County Jail would tell of Clinton's pacing back and forth in his cell. He would talk to himself, sometimes breaking out in bursts of laughter or tears.

The police were probably satisfied with the whole process and were no doubt glad they were finished with the horrible case. But before long, police started to hear stories from the prisoners in the jail. All of a sudden, no one wanted to be alone in their cells.

They reported hearing footsteps, as though someone were pacing in their cell. A man's voice was heard, sometimes mumbling or laughing. Newspapers stated that the number of men in the jail was actually dwindling.

While the police reported that St. Clair's execution was the reason crime was declining, the men in jail told a different story. They said it was because word had gotten out that the men incarcerated were afraid to be there. These prisoners had spread the story that Clinton St. Clair was still there in his cell, tortured by the crime he had committed, reliving his last few days on this earth.

7
FROZEN HEART

Jacob Maher was born in Russia on March 21, 1897. He came to the United States in 1911, though he had no relatives in this country. His parents died in Russia, and his only brother was killed in the Russian army. When he was older, Jacob joined the United States Marines. While he was in Rockford, he roomed at the home of Peter Egnitchuk at 1436 Nelson Boulevard. In 1924, he was working in Chicago but made frequent trips back to Rockford to visit his adoptive family.

Jacob Maher had been courting pretty Mary Ostrowski for two years, and they once talked of marriage. Mary Ostrowski was born in Russian Poland on June 26, 1905, and moved with her family to the United States around 1914. Mary quit high school in 1923 and went to work at Burson Knitting Company and also the Nelson Hotel. She was only sixteen when she met Jacob.

Recently, the love affair had soured when Mary's parents disapproved of Maher. Things came to a head in December 1923 when Mr. Ostrowski threw Maher out of the family home at 246 Catherine Street.

Jacob moved to Chicago to look for work. It was hard for Jacob to be so far away from Mary, and some days, instead of going to work, he would make the trip to Rockford to see her. She would usually scold him for skipping work.

Jacob had friends in Rockford, and they must have been keeping an eye on Mary for him. They told him that Mary had started to see someone new. The man was Stanley Barato, and he lived in Milwaukee. Mary wrote Jacob to explain that her feelings had changed. She tried to explain that she could

not continue to see him without her parents' approval. She also was honest about meeting another man. Jacob flew into a rage when he found out.

Jacob wrote Mary and tried to reconcile, but Mary was tired of the frequent arguments and let him know it. Jacob's anger scared her, and she refused to see him for the two weeks at the end of January and the beginning of February.

Jacob came to Rockford on Sunday, February 3, and went to the Egnitchuks' house. They were shocked to see him so depressed. Jacob spent Monday, February 4, 1924, walking around Rockford. People reported seeing him nervously pacing up and down the street even when it started to snow.

John Ostrowski, Mary's father, later explained to police that Jacob had made threats against Mary and her parents. The Ostrowskis' neighbors knew the situation and agreed to keep a watch out for Jacob. It was around 7:30 p.m. when the Ostrowskis' neighbors several blocks up on Catherine Street noticed a man walking nervously about the neighborhood. But a snowstorm turned into a blizzard, and the man had his head covered. They could not see his face to identify him.

John Rzeszotko was a neighbor of the Ostrowskis and lived a few houses away on Catherine Street. He owned a store at the corner of Catherine and Seminary Streets. At 8:30 p.m. on February 4, a phone call came in to Rzeszotko's store. The caller requested that someone go to the Ostrowski house and ask either Mary or John Ostrowski to come to the phone. The caller gave his name as Stanley Barato, the new man that Mary was supposedly dating.

Rzeszotko's store was only a few doors down from the Ostrowski home, so he ran to collect Mary or John. John left the house earlier in the evening, so Mary said she would go. Rzeszotko escorted Mary back through the snowstorm to his store. Mary rushed to the phone, no doubt excited to hear from Stanley. But when she picked up the phone, there was no one on the other end of the line. Mary waited a few minutes and then stepped out into the snow to return to her house.

Mrs. Conklin lived at 248 Catherine Street and was standing at her front window watching the storm. She saw Mary walking quickly by her house. Then she saw Mary stop suddenly.

Jacob was hiding under a tree waiting for Mary's return. He stepped out from the shadows and, without saying a word, raised his .32-caliber automatic and shot Mary through the heart. She had just enough time to raise her right hand. The bullet shattered one finger on the right hand and then pierced her heart.

After seeing Mary fall, Maher shot himself. He attempted to hit his heart, but the shot missed and lodged in his side. He clutched the gun and pressed the smoking muzzle to his forehead, right between his eyes. He pulled the trigger and fell across the body of his former sweetheart. Mrs. Conklin was the only witness to this horrible scene. She even saw the small flame that came from the end of the muzzle.

She summoned one of her roomers to accompany her and stepped out into the snow in her stocking feet. They were both horrified at the scene in front of them. Other neighbors heard the shots and came to join them. They found Mary was beyond help, but Maher was gasping for breath. They recognized Mary at once and knew immediately what had taken place. They stepped back silently to make room for Mary's mother when she came out into the blinding snow to find her daughter. They led her home when she became hysterical. A neighbor lifted Mary's body from the bloody snow and carried her into the house. The police and coroner were called.

Captain Read and his men made a careful investigation of the tragic event. The police checked Maher's pockets and found another magazine for the gun he carried. They also found a letter that Jacob wrote that explained the reason behind his deed. Maher wrote of his love for Mary and the promise of marriage that she broke. He described in great detail that he had no choice but to kill her. He wrote that he was going to "finish their love." The police believed that Jacob knew that Mary's father was visiting a neighbor and was not at home.

Mr. John Ostrowski, Mary's father, was interviewed by Captain Read and said, "I knew that something like this was going to happen. I thought for the last year that Maher would try to kill me and Mary together."

Mary Ostrowski's well-attended funeral was held at St. Stanislaus Polish Catholic Church not far from her home. A long line of cars followed Mary's body to the Catholic cemetery. Her friends and family were devastated by the loss, and Mary's mother could barely walk because she was so overcome by her grief.

Jacob Maher's friends had to make the arrangements for his funeral when Coroner Fred C. Olson failed to find any relatives. His funeral was held in the home of the Egnitchuks. Mrs. Egnitchuk was so distraught over the murders that she had to be hospitalized. Maher is buried in an unmarked grave in Cedar Bluff Cemetery in Rockford.

8

UNFATHOMABLE

Susan Brady and Cecilia Burns were very excited. They were helping clean blackboards in their classroom at St. Patrick's before heading over to Cecilia's house to do homework and listen to records. It was December 20, 1965, and it was chilly, so the girls bundled up before leaving the school. Susan had received new boots as an early Christmas present from her parents and was excited to wear them.

They left the school around 3:15 p.m. and walked to Cecilia's house on Irving Avenue. The time passed all too quickly, and soon it was time for Susan to go home for dinner. Cecilia offered to walk part of the way with her since it got dark so quickly at that time of the year. They walked to the intersection of School Street and Albert Avenue together before going their separate ways at 5:45 p.m. Susan still had quite a walk ahead of her to reach her house at 703 North Day Avenue. Cecilia was frightened by strange noises on the way home and looked back several time to check on Susan's progress. She would be the last person to see Susan Brady alive.

Susan was the daughter of James and Norma Brady. In 1965, they had three sons—Mike, sixteen; Tim, fourteen; and Tom, nine—and two daughters, Susan, eleven, and Nancy, five. James worked as a reporter for the *Rockford Labor News*.

Susan's mother, Norma, grew concerned as the sky darkened and the day turned into evening. Susan was always home by dinner. After James came home from work, they looked for her on foot, following the route that Susan would have taken home. They spoke to Cecilia, who told them she left Susan

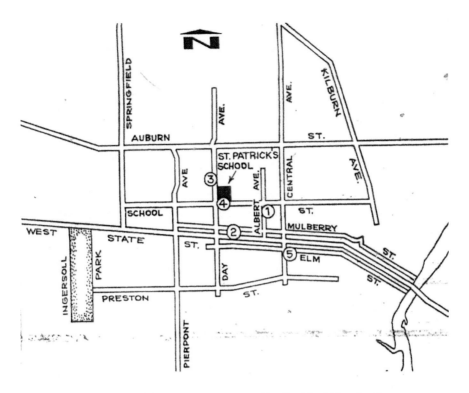

A map showing the area of Susan's disappearance. *From* Rockford Morning Star.

at the intersection of Albert Avenue and School Street. As the evening grew later, they searched with their car. Two hours after they started searching, they decided to call the police. James explained later that he didn't want to involve the police too early. The family really felt Susie would walk in the door any second. But of course, she didn't.

The next day, there was still no sign of Susan, and more people got involved in the search. On December 22, the search became a full-blown effort. There were men with dogs and others on foot who were divided into teams of five men accompanied by a police officer. These search parties were all coordinated from the Number 6 Firehouse at 430 North Springfield Avenue. Police Sergeant Robert Selgren coordinated the ground search and gave the over two hundred people who volunteered their last-minute instructions.

There were also ten airplanes taking part in the search under the supervision of Captain H.W. Lundberg. They were in the air looking for anything that should be checked out by the ground crew. Susan's father and

two elder brothers helped in the search. Norma sat in their beautiful home waiting for some word that Susan had been found, safe and sound. The house had been decorated for Christmas, and they plugged in the tree every night so the house would be all lit when Susan came home.

As the massive search was taking place, Susan's school held a special prayer service, and over six hundred students attended. Susan was in Sister Leora's sixth-grade class, and the day's newspapers had quotes from the teacher and several of Susie's classmates describing her. Sister Leora said that Susie was a good student, quiet, conscientious and helpful to her fellow classmates. Susan's friends said she was fun, friendly and that she loved to dance to her favorite group, the Beatles.

On Christmas Eve, the Brady family asked for a special Christmas wish. "Our only request is that everyone pray for her safe return and keep looking in their yards to see if they can find her," James Brady was quoted in the paper. They also thanked the community for the great response. Many people helped by taking part in the search, answering the telephone, bringing food for the family and volunteers and assisting with the other Brady children. The whole community seemed determined to find this little girl.

The family also received a very special gift from Bishop Loras T. Lane of the Rockford Diocese who had just returned from the Vatican. The bishop brought the family a special wooden figure of the Virgin Mary holding the baby Jesus that had been blessed by the Pope. He gave the family the beautiful gift on Christmas Eve.

There was a $2,500 reward offered for information leading to the safe return of Susan by the *Rockford Register-Republic* and the *Rockford Morning Star*. Other people gave money toward the reward, including a number of children. Later, the chamber of commerce added another $1,000 to the reward.

The hunt for Susan continued. One search was focused on the Sugar River area; in January, the focus became the Burr Oaks Road area. Deputy Sheriff Michael reported that between forty and fifty members of the Purple Knight Drum and Bugle Corps from St. Patrick's School and the Loves Park volunteer fire department participated in that search area.

The Christmas tree at the Brady's house still stood with the lights twinkling every night even through the middle of January. Susan's father said, "We still are hoping to have our family's Christmas celebration." He went on to say the family was back to normal on the outside, returning to work and school. But underneath, they still jumped every time they heard a car pull into the driveway or the phone rang.

Around the middle of January, claims from several young girls came to the police's attention. One girl said that on the day that Susan went missing, December 20, 1965, she was walking just a few blocks from where Susan was last seen. The twelve-year-old little girl was walking home on the 1300 block of Blaisdell Street around 5:30 p.m. A man driving a 1961 green Cadillac pulled over to the side of the road and asked the girl if she wanted a ride. The girl refused, turned the corner and walked quickly away. The man drove away in the same direction where Susan was walking home. Police asked for information from anyone who might have seen the car or the man described by the little girl.

The Brady family was very forthcoming about the agony their family was going through. As the police search spread and the searchers began to look into cisterns and wells, the family was still waiting for the phone to ring. The Bradys hadn't told their youngest child, Nancy, about Susan's disappearance. They sent the little girl to friends' houses to spend time there. "We are trying to keep her away from home as much as possible. This house is not the right atmosphere for a child," Norma stated.

The Bradys were very touched by how wonderful and compassionate people had been to them. Cards, telegrams and well wishes arrived at the house every day. These cards were not just from Rockford but from all over the country.

Valentine's Day 1966 started out as a bright, crisp day but quickly turned dark as the family finally learned what happened to their beautiful young daughter. The family's hopes for reuniting with Susan were completely smashed. James and Norma were told that twenty-five-year-old Russell Charles Dewey surrendered to FBI agents in California after returning from a flight to Mexico.

The older boys were brought home by a priest from St. Patrick's, and the younger boy was met by his family for a special Mass. Again, James and Norma impressed all who knew them by their graciousness in the midst of this awful tragedy. "At least now we know," they both said, explaining that the worst thing was imagining what might have happened. It didn't make it any easier, but at least they knew that their little girl was in heaven, beyond any pain and fear.

The police became suspicious of Dewey when reports by the little girls of a man in a 1961 Cadillac stopping them to offer a ride home. Dewey owned such a car until January 4, when he sold the car to Genrich and Harris Auto Sales. A day later, he quit his job and left for San Diego.

During questioning, Dewey stated that he was driving on School Street around a quarter to six in the evening when little Susie ran right out in front of his car near St. Patrick's Church's driveway.

Dewey scooped Susan up and placed her in the front seat on his trench coat to rush to Rockford Memorial Hospital for medical treatment. He drove as fast as he could, but when he reached the entrance, the little girl was dead. He checked her heartbeat and pulse but it was no use, she was already gone. Dewey became frightened, he said, because he had no insurance and was afraid of being sued.

Later on February 14, at a press conference, Rockford Police chief Delbert Peterson shared the sad news of Susie's death and Dewey's arrest for the crime. "I'm proud today to be a police officer," Peterson stated. He was proud of the police force for finding the clues that led to the arrest of the person responsible for what happened to Susie. Peterson explained to reporters that Dewey had admitted killing Susan but stated that it was an accident. Peterson also reported that they had found no evidence of Susan in the car. State's Attorney William Nash then spoke to describe some of the clues that were followed to solve Susan's murder.

The men described the search for the car reported by the little girl. Following this lead, they came upon Dewey's name for the first time. Their suspicions grew when they found out he had sold the car, quit his job and then left town after Susan's disappearance. The police involved the FBI to hunt Dewey down while they started to look for evidence in Rockford. The police found out that Dewey had moved in with Mr. and Mrs. Floyd Carruthers, his grandparents, during the summer of 1965.

The police searched the Carruthers home after the reports from the attempted kidnap of the little girl on same the day Susie disappeared. The search led to finding an incinerator made from a fifty-gallon drum. They also found some suspicious matter in the ashes in the bottom of the can that appeared to be human bone. The police sent that to the FBI lab in Washington, D.C. It would eventually come back as being bone from a child eight to twelve years old. A fugitive warrant was issued for Dewey.

Dewey admitted he was staying at the Carruthers house during December while his grandparents were in Florida. This is where he decided to take Susie after he realized she was dead. He told police that he panicked after he realized that she was dead and he drove to his grandparents' house on West State Street near Meridian. It was here that he jammed Susan's body, book bag and his trench coat into a fifty-gallon incinerator. He used gasoline to set the items on fire.

Dewey was shocked when his uncle stopped by the house for a visit. He convinced the uncle to join him inside the house to watch television. Dewey stepped out to check on the fire several times. There were some larger pieces

of bone left, and Dewey disposed of these in the Winnebago County landfill located next to the J.L. Case Plant where he worked.

The police didn't believe Dewey's story of an accident. They felt that he had abducted little Susan and taken her to the garage behind his home, where he killed her with a sledgehammer.

It took some time before Dewey was brought back to Rockford. Dewey was very concerned about returning to Rockford because he didn't think he would get a fair trial there. Assistant State's Attorney Alfred Cowan flew out to San Diego to serve the warrant for Dewey's arrest for the murder of Susan. Dewey was returned to Rockford in March. His attorney argued for a change of venue, and it was finally decided that the trial would be held in Sycamore.

On February 22, 1966, St. Patrick's Church held a memorial service for Susan. Hundreds of family, friends, classmates and members of the Rockford community came together

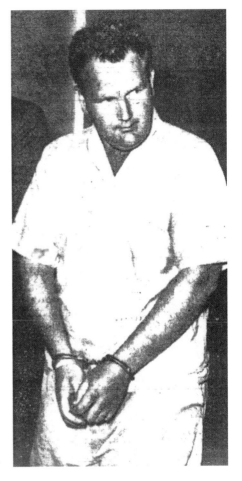

A photograph of Russel C. Dewey. *From Rockford Register Republic.*

to pay their last respects for the little girl so many had searched for and prayed would be returned safe and sound. The church was filled with beautiful flowers and the sounds of music. The Brady family was there with other family members. Many who attended spoke of being impressed with the inspirational way the Brady family conducted themselves. The Brady family asked the community for fair treatment of the man who killed their daughter.

The trial of Russell Dewey began on August 8, 1966, in Sycamore, Illinois. Roy S. Lasswell was Dewey's defense attorney, State's Attorney William Nash was assisted by Assistant State's Attorney Alfred W. Cowan and circuit judge Charles G. Seidel presided over the trial.

Dr. J. Lawrence, physical anthropologist at the Smithsonian in Washington, D.C., testified about the largest piece of bone found in the incinerator as being "a vertebra from an immature person." He also testified that the other bone fragments found came from a child eight to twelve years old.

Four little girls also testified during the trial and told the jury how a man in a green 1961 Cadillac had approached them. When asked if they could identify the man, all four did not hesitate as they pointed to Dewey sitting at the defense table.

In a dramatic moment during the trial, Lasswell grabbed an axe that was sitting on a desk, picked up the axe and hurled it past the jury back into the corridor, just missing a deputy sheriff by six inches. "That's not to be in the courtroom and you know it," he shouted at the judge, referring to the judge's decision not to allow the axe in the courtroom at the end of the trial because the part it played in the alleged murder was not made clear. Judge Seidel remained calm and told him to sit down, and a court bailiff retrieved the axe and returned it to the courtroom.

Norma Brady, Susan's mother, was the last of the thirty-three witnesses called by State's Attorney Nash. Her sorrow was hard to witness, and many in the court had tears in their eyes when she stepped from the stand. The defense called thirteen witnesses, and Dewey was the last to testify for the defense.

On August 22, the Dekalb County jury deliberated for three hours and forty-seven minutes. They had the choice between verdicts of not guilty, guilty and guilty with the recommendation of the death penalty. Judge Seidel warned that he would tolerate no outburst as the verdict was read. Jury foreman Frank Kuzan handed the verdict to the clerk. The air was thick with tension as everyone waited to hear the verdict.

Dewey did not even look up as deputy circuit clerk Wayne Luhtala read the verdict. Russell Dewey was found guilty of the murder of eleven-year-old Susan Brady. He showed no emotion, but his first wife, Sandra, was in the courtroom and began to cry. Dewey patted her arm as if to comfort her. His mother and grandparents were also in the courtroom and were obviously shaken by the verdict.

Dewey apparently did his time without any further incidents, and news came in February 1987 that Dewey would be released in April. There were a lot of people who were angered by the release. Dewey was originally sentenced to twenty to fifty years but was released after serving twenty.

Dewey was born in Rockford on December 9, 1940. His parents were Charles and Ardith Dewey. His father died when he was very young, and his

mother remarried three times. Dewey dropped out of high school and found employment in a factory and then as a landscaper.

Russell Dewey was married the first time to Sandra Jean on December 21, 1963, and divorced her on April 10, 1964. Dewey next married Sue E. on August 22, 1964, and divorced her on August 12, 1965. He charged both of the women with mental cruelty. Sandra and Russell did attempt reconciliation during November and December 1965, but Sandra returned to her second husband. There was nothing in Russell Dewey's background to indicate that he was capable of such a horrible crime.

Susan's memory was honored by the opening of the Susan Brady Memorial Library at St. Patrick's Elementary School. The Bradys dedicated the money that had been donated by community members, students and the chamber of commerce.

On the anniversary of Susan's twentieth birthday, St. Patrick's Church held a special memorial Mass in her name. Susan and her family are still remembered by many in the city of Rockford, and 2015 will mark the fiftieth anniversary of her death. The little girl who disappeared so long ago joined this community together in a way that nothing had before. Her death touched everyone, and some would say that it changed Rockford forever.

9
LOSS OF INNOCENCE

Some people call it woman's intuition; some may dismiss the notion. No matter what you may believe, the fact is that on that day Mrs. Mullendore was worried. She had a bad feeling all day and just could not shake it. It was March 1967. Winter had not loosened its grasp completely, but March 3 was full of the promise of warmer days. Mrs. Mullendore spent the day in typical fashion; she worked around the house and made an early dinner.

Her son, Wayne, got home from school around 3:45 p.m. He was a seventh grader at Wilson Middle School. Mrs. Mullendore asked Wayne to run to the grocery store for a few things that she needed to finish dinner. The family was going to attend church that evening, and she was in a hurry to get the dinner on the table.

The family ate dinner, and then Wayne asked his father for permission to spend the evening with his cousin, Ronald Johnson, whom everyone called Chuck. Mr. Mullendore gave his consent. He dropped Wayne off around 6:30 p.m. at Chuck's house on Elm Street, promising to pick him up around 9:00 p.m. The rest of the family went to church. Later, Mrs. Mullendore was sitting with an elderly friend watching television. She still had that nagging feeling from earlier, the feeling that something terrible was going to happen. It was while she was with her friend that she heard the first report of breaking news. There were two teenaged boys found at Levings Lake Park.

Mrs. Mullendore mentioned her feeling of dread to her husband when he picked her up. Her husband just brushed off her concerns. They

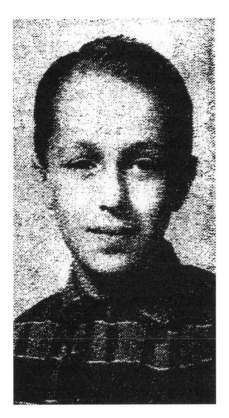 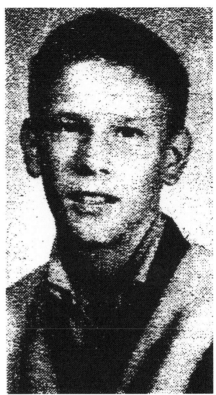

Left: A photograph of Wayne Mullendore, fourteen, in 1967. *From* Rockford Morning Star.

Right: A photograph of Chuck Johnson, fourteen, in 1967. *From* Rockford Morning Star.

stopped at the Johnsons' house to get Wayne and were surprised when Chuck's father said the boys weren't there. They had gone to visit with a friend and hadn't made it back yet.

Mr. Mullendore didn't say anything to his wife, but his apprehension was growing as well. They went home and put the other children to bed. They were watching the news when the story was announced again, this time with more details. Two teenaged boys had been discovered at Levings Lake Park. The report described what the boys were wearing and mentioned a scar on one of the boys' stomach.

The Mullendores didn't say a word to each other. They were both remembering that day ten years prior, when Wayne was four. Another cousin and Wayne were playing in the kitchen of the Mullendore house. The cousin was crawling under the table when his foot got caught on the cord

of the coffeepot, overturning the pot and splashing hot coffee onto Wayne's stomach. The burn left a distinctive scar.

Mr. Mullendore walked to the phone and slowly dialed the telephone number of Rockford Memorial Hospital. The person on the phone asked Mr. Mullendore a few questions and offered to have a police squad car pick him up to bring him to the hospital.

Mr. Johnson, Chuck's father, was also starting to worry. He sent Chuck's elder brother to friend Sandy Cain's house around 9:30 p.m. Sandy told the brother that the boys had called her earlier, and she said they could visit her after 7:30 p.m. at the house where she was babysitting. The boys promised they would come, but they never arrived.

No one knew for sure what happened that night. The police only knew that a phone call came in at 8:16 p.m. It sounded like a young woman's voice. The caller stated that two boys had been shot at Levings Lake.

The police showed up in record time, arriving at 8:18 p.m. The first officers on the scene were Sheriff's Deputies Frank Englund Jr. and Samuel Ritter. Both officers were understandably on edge when they arrived at the scene. The night was foggy, and it hung low over the whole area that night, adding to the eeriness. The fog dimmed the single light that shone from the pole by the shelter.

Englund reported that he covered Ritter as he ran to the pavilion. "We pointed our spotlight into the pavilion and saw two bodies against the west wall," Englund said.

The officers were so busy trying to get help for the unconscious boys that they didn't really notice how young the boys were. They did notice that one boy had his hands behind him and the other had his hands in his pockets. They were both face up and the pools of blood were still forming when they were found.

The ambulance arrived, and the boys were taken to Rockford Memorial Hospital. The looks on the faces of the officers and the paramedics said it all. They all knew they would be investigating homicides.

Chuck Johnson was pronounced dead when the ambulance arrived, but Wayne was still fighting for his life. It must have been very chaotic in the emergency room; they had two unidentified boys, one dead and the other dying. They didn't know who their parents were or why the boys had been out at the lake. Wayne Mullendore would die before his father reached the hospital.

Meanwhile, two families were growing more frantic as the evening wore on. Victor Johnson was Chuck Johnson's father. He worked for the Time Screw and Manufacturing Company. When his elder boy finally returned

to the Johnson house, the news had started, and Victor Johnson heard the same descriptions that Mr. Mullendore had. Another squad car was sent out for the Johnson family.

In an article written much later, in 1973, Victor Johnson spoke of what it was like that evening. The first table he came to held the body of his nephew, Wayne. He went on to describe the horrific scene. "I almost passed out, knowing somewhere in that room was my son. Moving further into the room, the sight that greeted me was one which will never leave me. My son was lying on one of the tables with a bullet wound in his stomach. I did not know at the time that he had a hole in his head also."

The police worked the case "around the clock" and were at Levings Lake in full force, trying to piece together what happened. Sheriff Herbert Brown was leading the investigation and was quoted in the *Morning Star* newspaper as believing the case was premeditated and that "it may have been the work of a juvenile because it appears to have been an execution, done with ceremony."

The police had a theory that someone met the boys, forced them into a car and brought them to the lake. The boys were made to kneel at the back wall of the stone shelter and were each shot once in the head. After they fell, they were each shot in the stomach. It must have been terrifying for the two boys all alone in the deserted park with a person holding a gun.

The clues were few and included some threads found outside the shelter that might have indicated a scuffle. But there were no other signs of a fight. It appeared to the police that the boys did not fight with their attacker before being shot. This led the police to believe there might have been more than one person involved.

The police also found part of a rubber heel inside the shelter. It was not from either of the victims' shoes. These items were sent to the state mobile laboratory that was brought from Joliet to assist with the investigation.

The police were also working the phone call they received that had reported the murders. They implored whoever called in to "please help us" by calling back and giving more information. They were relatively certain that the caller must live outside the city limits because they dialed the sheriff's office and not the Rockford Police Department.

A $2,500 reward was offered by the families and the newspaper to help generate leads in the case.

The Rockford Police Department was assisting in the case by conducting a door-to-door search in the area of the West State and Johnson Streets. This was the area where the police believed the boys were met by the person in the car.

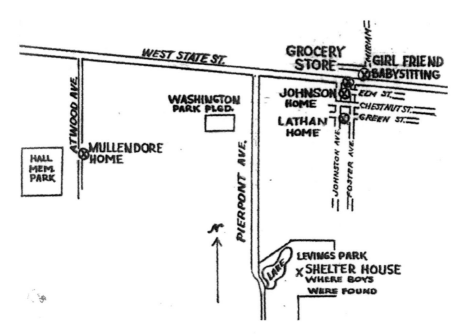

A map showing the key points in the double slaying. *From* Rockford Morning Star.

The papers from March 4 were also filled with students, teachers and neighbors remembering the two boys. All of the stories described how kind both of the boys were. Both boys were described as "soft spoken, polite and well-behaved." Wayne's mother stood in his room filled with sports trophies and talked of how he was so hard working on his paper route and always willing to help his parents around the house. He played baseball, basketball and bowling.

Chuck's neighbors spoke of him shoveling their snow or mowing their yards. His best friend was Chuck Lathan, whose parents spoke highly of Chuck Johnson. Johnson was quite a baseball player and was scheduled to be the head pitcher for the Sport Center Team in the Bronco Baseball League that spring.

Police were able to put together a timeline of the boys' activities for the evening. Chuck Johnson's mom sent the boys to the Po-Jo Supermarket on West State Street to buy some sandwich meat for Mr. Johnson's lunch the next day. The boys stopped at Mauk Drug Store also on West State Street to phone Sandy Cain, who invited them to the house where she would be babysitting.

The boys stopped at Chuck's house to drop off the sandwich meat around 7:30 p.m. That was the last time anyone saw them. The call notifying

the police of the shootings came in at 8:16 p.m. Police were desperate to find out what happened in that forty-five-minute window of time.

The woman who hired Sandy Cain to babysit, Mrs. Donaldson, stated that she was running a little late that night and left to pick Sandy up at 7:30 p.m. She noticed a car parked on the wrong side of the road just down from her house. When she returned with Sandy, the car was gone.

The news of the shootings spread like wildfire. NBC and CBS sent reporters and cameramen, and the local newspaper reported that it received hundreds of calls from newspapers from New York to the West Coast.

Wayne and Chuck were buried on March 7, 1967, at Willwood Burial Park. Over seven hundred people attended the funerals and graveside service, and over one hundred vehicles made the long, silent drive from the Julian-Poorman Funeral Home down West State Street to the burial site. According to the funeral home staff, this was the biggest service they ever facilitated.

The boys' matching silver caskets were draped with flower arrangements of red roses and white lilies. Over one hundred other plants were sent to honor the cousins. Their families stood by the coffins during the ceremony. Many in the crowd were classmates of the boys, and their principal and counselor attended to represent the West Middle School teachers. Their tear-streaked faces spoke of their sorrow.

It was during the solemn ceremony that the first whispers were heard. These whispers proclaimed that Sheriff Herb Brown was, at that very moment, questioning someone for these brutal murders.

John Wesley Williams Jr., a seventeen-year-old African American, had been arrested as a suspect for the killings. Williams's father had purchased a .22-caliber handgun for him the day before the murders. John Williams Sr., a former Winnebago County sheriff's deputy, had several other guns he owned. The police confiscated Mr. Williams's guns, but the new gun was not found.

John Wesley Williams Jr. had been recently found innocent of a sniper wounding charge. The shooting of the fifteen-year-old victim had taken place just a few months prior to this charge. He was also awaiting a trial on a reckless conduct charge involving another sniper incident.

Williams had an alibi for the night of the murders. He was married to a sixteen-year-old girl named Linda. She said that Williams was home with her having dinner at the time of the shootings. Police felt that the other evidence in the case would prove that Linda was lying about Williams's whereabouts.

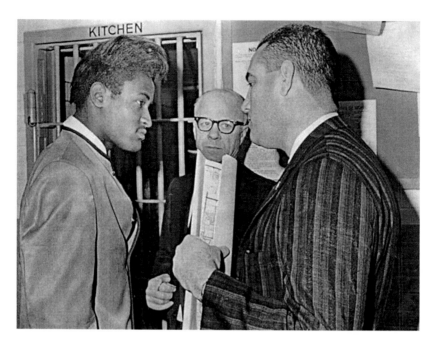

A photograph of John Williams Jr., seventeen, convicted of the double slaying. *From Rockford Morning Star.*

On the same day the arrest was announced, there was another article from the mayor stating that everyone must uphold the law. He pleaded with the readers to let the police and the courts handle the case. Obviously, there were concerns about vigilante justice.

The chamber of commerce added another $1,000 to the $2,500 reward already pledged as an incentive for witnesses to come forward. A grand jury hearing was held, and the jurors felt there was enough evidence against John Wesley Williams Jr. to hold him for trial. The grand jury heard from nine witnesses. The last one was Jon Moore, eighteen, an acquaintance of Williams. Moore testified that he saw Williams on March 1, 1967. Williams showed him a revolver that his father had just purchased for him and made the statement that he wanted to "go out and shoot someone." This was the day before Wayne and Chuck were shot.

Another witness was a gun store owner from the Rockford Discount Sales on East State Street who stated that Williams had visited his store on Tuesday, February 28, but he was just looking. On Wednesday, March 1, Williams returned and brought his father. They looked at a few guns and decided on the Rohm RG 24 .22-caliber revolver.

Police declared that both the Williams men denied owning a .22-caliber revolver. After the police revealed the statement from the gun shop owner, Williams Sr. said he had not seen the gun since he bought it for his son.

John Wesley Williams Jr.'s trial began in June 1968. State's Attorney William R. Nash was the prosecutor for the case. The defense attorneys were New York attorney Seymour Friedman and Rockford attorney Sam Dean. The jury consisted of seven women and five men. The judge was Chief Justice Albert O' Sullivan.

Since the case had such massive media coverage, the judge ordered the jury sequestered. They stayed at the National Motor Inn, now the location of a senior citizen high-rise apartment building. They were not allowed to look at magazines or newspapers, and the televisions were removed from their rooms.

One of the witnesses called was the owner of the Rockford Discount Sales, James Anast. His testimony was the same as it had been before the grand jury. He sold a gun to John Wesley Williams that was the same caliber as the murder weapon.

Another witness, James Rose, seventeen, who worked as a bag boy at the Po-Jo Supermarket on West State Street, testified that he saw an African American male in the store at the same time that Wayne and Chuck were there.

The main incriminating evidence was found right behind John Williams's house. Some men who knew Williams told the police that he had a "target practice area" behind his house. When the police followed through with the tip, they discovered slugs that Williams shot from the .22-caliber revolver. The bullets that were recovered from the autopsies were in good enough condition to be compared with those found at the house. They matched.

The trial lasted for four days, and the jury found John Wesley Williams Jr. guilty of the murder of the two boys.

Linda Williams, the sixteen-year-old wife of the murderer, attended the sentencing. The couple lived with Williams's parents. They were helping Linda take care of her and John Wesley's baby. The child was only one month old when Williams was arrested for the murders.

Chief Justice O'Sullivan sentenced John Wesley Williams to serve ninety to one hundred years for the two murder convictions, to be served concurrently. He would be eligible for parole after serving eleven years and three months. Williams was to be delivered to the Illinois State Penitentiary in Joliet, Illinois.

When he heard the sentence from the judge, Williams stated, "That's alright with me." He was allowed to visit with his wife for a couple of minutes before being led away.

John Wesley Williams Jr. was born in Rockford on June 17, 1949. He grew up here, attended school here and went to high school at Auburn High. He left school after tenth grade. He was employed as a spinner for Custom Metals. Williams was just an average guy. So what would make this young man—who had a job, had just gotten married and had a new baby—commit this horrible, senseless crime? That question has never been answered.

In July 1972, Williams was serving his sentence in Menard Maximum Security Prison in Chester, Illinois. He proclaimed his innocence from the very beginning. On July 4, 1972, Williams took the headphones that were supplied in his cell and wrapped the cord around his neck. He slowly slid down on the floor and stayed there until he passed out. John Wesley Williams Jr. hung himself in his cell. He was twenty-three years old.

In December 1973, Victor Johnson, father of Chuck Johnson and uncle of Wayne Mullendore, wrote a letter to the editor of a local newspaper. In this letter, Mr. Johnson told of how difficult it was to live without his son and how much he missed him. He also spoke of the man who killed his son:

The killer of my son is dead now and I feel better, knowing I will not have to kill him. This Christmas Season is a lonely one for me, and it probably will be for the rest of my life. Some people say "You will get over it," but they don't know the agony my wife and I go through every year.

People say it is good to talk about it, but who is there to go to? No one I know has gone through this, and we have to carry this burden alone. But with God's help we will make it. I ask all the people to pray for us to help us to carry this burden. And I know that the family of this killer is in the same position that we are, having Christmas without their son.

We offer our prayers to them, and maybe some way God can comfort both families. We are praying for them.

Part II
MAYHEM

[Tragedy] *is neither a punishment meted out nor a lesson conferred.*
Its horrors are not attributable to one single person. Tragedy is ugly
and tangled, stupid and confusing.
—E. Lockhart

10

COLLAPSE OF THE WINNEBAGO COUNTY COURTHOUSE

Winnebago County decided it needed a brand-new courthouse to meet the needs of the growing area in 1875. The population of Rockford at this time was around twelve thousand people, and the town had twelve churches, five banks and several newspapers. The courthouse project was advertised, and many plans were submitted until, finally, Henry L. Gay's design was accepted. W.D. Richardson was the contractor hired to build the newest Winnebago County Courthouse, and F.E. Latham was the supervisor of the project.

W.D. Richardson was a contractor from Springfield who had experience building the French Venetian style of building that was selected. Work began in the spring of 1876, and the cornerstone was set on June 22, 1876, with great fanfare and led by the state's Masonic lodges.

The domed roof was to be the "jewel in the crown" of the building and originally was scheduled to be set in 1876. The weather didn't cooperate, and the whole project was behind schedule for several months. It was not ready for the dome to be added until the spring of 1877.

On Friday, May 11, 1877, at around 11:30 a.m., W.D. Richardson and F.E. Latham were inspecting the domed roof and walls. They were discussing their concerns about the strength of the walls supporting the dome. Richardson heard the horrific sound of something cracking, and both men ran to the northwest corner of the building. They just had time to reach the west wall when the front of the building fell.

"Just as the keystone was being placed in the dome of the main pavilion the brickwork between the iron and the stone gave way, and the entire dome

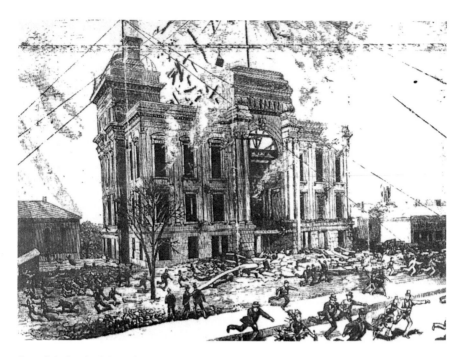

An artist's sketch of the collapse of the courthouse in 1877. *From* Rockford Morning Star.

and interior walls of the structure came crumbling down with a terrible crash, which was heard nearly a mile away." The crash was tremendous, and a wall of dust sprang up where the wall once stood. Spectators hesitated just for a moment before they rushed forward to see what could be done for the twenty or so men working inside the structure.

Timothy Flanagan was one of the men working that day. His task on that Friday morning was to set the keystone in the pediment of the dome. Flanagan was working up at the top when the wall started to crumble. The crowd below looked on in horror as Flanagan leaped across in an attempt to grasp the main guy rope. Flanagan missed the rope and fell one hundred feet to the ground below, his body hitting the ground with a sickening thud.

Several men ran forward, picked up Flanagan's body and put it on the lawn of the courthouse. The masonry fell from all sides, and men's screams could be heard above the roar of the falling stone. Men were seen hanging from ropes on different parts of the building, while others were jumping from windows.

Men from the crowd rushed forward to assist with the rescue efforts as others ran for doctors. The rescuers uncovered several men quickly. One of the first men uncovered was Andrew Bildahl, who had a terrible gash on

his head that was filled with ash and mortar. He was loaded into a cart and taken to his home to have the wound dressed.

William McInnes of Rockford was almost completely buried, but the men quickly got him out and loaded into a cart to be delivered to his home. He suffered a broken leg and numerous injuries. George Gloss was so badly mangled that the sight of his body visibly shook the crowd. He was smashed and was missing a leg. He was carried over to the old courthouse, which was set up as a temporary morgue.

Two more men were saved from the fire escape, led to safety by Chief Engineer John Lakin. The word had started to spread throughout the city, and others came to assist. Family members rushed to the building to hear the condition of their menfolk. Many of the men working on the building were from the area, and friends would peer into the faces of the men as they were brought out of the debris. They were either loaded onto a wagon to be transported to their homes or laid in the old courthouse to wait to be identified.

Some of the men were from Springfield and had no family members living nearby, but they had acquaintances who ran to help. The injured men from Springfield were taken to the City Hotel to have their wounds tended.

There was a wretched moment when a poor German woman came forward screaming her husband's name, Albert Haug. When his body was finally brought out, it presented a ghastly spectacle for all to see. His poor body had been pulverized and torn by the large stones that fell on him. The men rushed him through the crowd to the courthouse as quickly as possible.

Scene after heart-wrenching scene played out as the rescuers continued to dig for the men. A little girl wandered through the crowd crying for her papa. No one had the heart to tell her that he was still missing. His body would not be found for another day.

The inquest was started as soon as the bodies were laid out in the courthouse and covered with cloths. The purpose of this inquest was not to determine the cause for the accident but to identify the dead men. Other men were still missing, and the rescue efforts continued for days. Around 12:00 a.m. on Saturday, one of the workers came across a clump of human hair. It was shortly found to be A.E. Hollenbeck's scalp. His body was pinned under a massive stone weighing several tons. Drills were brought in, and parts of the rock were drilled off until the only part still trapped was his arm. The decision was made to cut the arm off to free the rest of the body. The top of Hollenbeck's head was completely gone. As they removed the rest of Hollenbeck's body, they uncovered another man. "Big Fred" Haug was from Springfield, and his body was so ghastly that no description of the remains

was given. These last two bodies took over four hours to uncover. In all, it took over forty long hours for all the bodies to be discovered.

Trains arrived from all over northern Illinois as people flocked to Rockford to see the remains of the building. The police roped off the dangerous area and stood guard to keep the crowds at a safe distance.

When the totals came in, seven men were killed immediately and two others died later; another twelve were wounded in the tragedy. Funerals were held, and more was learned of the men who died. Hollenbeck was forty-five years old and had been born in New York, like many of Rockford's early settlers. He was a Mason and was buried with full Masonic honors. Over one thousand people attended his funeral.

Fred Haug left a wife and four children in Springfield and was a brother of Chris Haug, who formerly owned a marble yard here. Albert Haug was a son of the above-mentioned Chris Haug and left a wife and children in Rockford.

John Pipe moved to Rockford in 1875, and his father was the foreman on the courthouse project. George Gloss, who lived in Rockford, was an African American who left a wife and three children. John Warren, another African American, worked as a rigger and lived in Rockford with his wife and three children.

Frank Harris, the blacksmith, was on the roof when the courthouse fell. He advised a co-worker to run, but then he turned the other way. The co-worker lived, and Harris fell with the building. He was pulled from the ruins with a badly crushed leg. Fred was taken to the City Hotel for treatment, which included amputation of his leg; unfortunately, gangrene set in. Harris was the ninth man to die. He was only twenty-four years old and lived in Dixon. His family members came to retrieve his body and took him home for burial.

Inquests attempted to answer the questions left by the horrible accident. The articles in the paper seemed to point the finger at the architect, Mr. Gay. The same articles praised the builder, Richardson, stating that at personal cost, the builder added improvements to increase the safety of the building. Richardson had also impressed everyone with the care he gave the wounded men and their families.

The coroner's jury investigated the accident for over twelve days, interviewing workmen, the architect and other architects who studied the design. In the end, they found the architect guilty for the flawed design, and the contractor and the county board were found guilty of negligence for not noticing the flaws. A new architect and designers were hired to assess

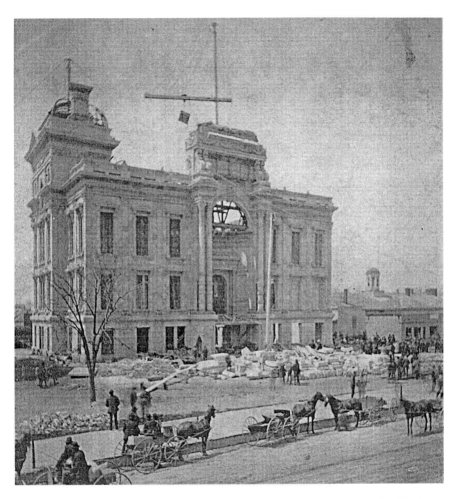

A photograph of the damaged Winnebago County Courthouse in 1878. *From* Rockford Morning Star.

the damage caused by the falling dome and to complete the project. The courthouse was finally completed with the dome, and the building was dedicated in October 1878. The final cost was $211,000.

An excerpt from the May 18, 1877 *Rockford Weekly Gazette* stated, "Never before has any public affliction found its way so near to the doors of our own homes or been made so sacredly our own."

11
TRAIN WRECK OF 1901

The winter night was quiet and peaceful under the twinkling of the star-filled sky; the next moment, it was as if the earth had split open and exposed hell itself. The worst train wreck in the history of Winnebago County happened shortly after midnight on December 15, 1901, when a passenger train and a freight met in a devastating head-on collision. The wreck occurred two miles east of Perryville on the Illinois Central Railroad.

Ten people were killed instantly or shortly thereafter in the flames that enveloped the wreck. Another twenty-four people were injured in the horrific crash. The crash took place between a fast Omaha flyer passenger train that was headed toward Chicago and a westbound freight train. The passenger train was behind schedule and was trying to make up time. The freight train was aware of the delay of the passenger train and had adjusted its speed to allow it to pass the eastbound train.

The two trains met on a short curve and smashed head on into each other, and the metal beasts crumpled as though made of paper. The front cars on the passenger train passed up and over the heavy freight cars that plowed through the cars crumpling, crushing and killing. The remaining cars toppled over with a thud, and the trains screeched to a stop.

There was an incredible, awful silence for just a moment that was soon broken by hissing steam from the train and the screams of the wounded. Then, a few minutes later, the ominous sound of the crackling of a fire. The shouts of the survivors grew even more frantic as they worked to extract the wounded before they were burned.

Then, just when they thought the danger couldn't get any worse, the boiler on the freight train exploded and ripped the mangled cars apart, multiplying the terror. This caused some of the survivors to panic and added to the confusion as men and women ran back and forth, not knowing exactly what to do. But this was temporary, and as happens in cases like this, some men stepped forward to take charge and direct the rescue efforts.

There were several cars, including the caboose, that were not damaged. These were pushed back away from the flames and used as a place to put the survivors. It was imperative to act quickly because the temperatures on the December night were dropping dangerously below zero.

Word was sent to the small town of Irene, and requests for assistance were forwarded to Rockford and Chicago. Both cities worked to gather rescue workers and items that might be needed. Rockford's rescue train set out at 1:40 a.m. and contained several doctors, coats, mittens, first-aid supplies and blankets.

As the relief train approached the area where the disaster happened, all aboard noticed the sky was a strange orange color. They were filled with horror when they realized that the color was indicating the worst-case scenario: the trains were on fire.

Everyone worked quickly to load the injured and survivors on the rescue train and rush back to Rockford. It pulled into the central station to meet any available vehicles. Ambulances, patrol wagon and even the Chick House Hotel bus were all waiting to transport the wounded to the hospital.

Some of the wounded were treated and released that night. They were taken to Nelson Hotel for the evening before returning to their homes the next day.

The men from the freight train included David Behan of Freeport, the engineer of the freight train. His body was crushed and burned beyond recognition. Edward P. Carey was the fireman on the freight train and, like the engineer, was crushed and burned.

The men from the Omaha passenger train included Richard W. Ormsby of Chicago, the engineer. James Reardon was from Freeport and was the fireman on the passenger train. They, too, were killed instantly, but these men were later considered the fortunate ones. Three men were trapped in the smoker car. Others who escaped the train tried desperately to save them, but they were burned to death in the fire. George and William Reynolds were brothers who worked on the railroad as section foremen, and they died with Bert Coates, a Chicago newsboy. Their screams would haunt the men who attempted to rescue them.

Mrs. Williamson was on the train with her infant. She couldn't tell anyone how she escaped. She only remembered crawling through a window after the explosion.

Never before had the nurses and doctors been so challenged as they were on the night of the wreck. Henry Wellman, one of the first to be treated, had his arm ripped to shreds and his head gashed. He was weak from loss of blood and exposure to the cold temperatures. His arm would later be amputated.

Coroner F.M. Marsh from Rockford took charge of the crash victims as soon as jurisdiction was established. Ormsby's, Reardon's and Carey's remains were taken to Marsh's undertaking house, and a coroner's inquest was arranged. Daniel Reardon identified his brother James's remains by a service medal that was pinned to his pants.

There were no witnesses called to determine the cause of the crash. Everyone who might have seen the accident had been killed. Edward P. Carey was also identified by a brother, and Richard Ormsby, the engineer, was identified by J.W. Mayer, a locomotive engineer who lived in Freeport, using pieces torn from a pocket and an Illinois Central Souvenir Medal with the man's name on it.

Jerry Turner, an Irene farmer, was originally listed as missing and was presumed dead. Jerry later turned up very much alive but couldn't answer questions about how he got out of the wreckage. Another Irene woman, Mrs. Sadie Koch, was sharing a seat with Mrs. Williamson of Ohio when the crash happened. Sadie was thrown the whole length of the car and suffered a broken arm. Before making her escape through a window, Sadie helped others to safety. She decided to finish walking to her home in Irene. It was while walking home that she ran into Mr. Turner. The older man seemed dazed and not really sure where he was going. He told Sadie he got out of the wreckage and just started walking. She noticed he was bruised but otherwise seemed unhurt. Turner continued on to his own house after leaving Sadie.

Frank Rideout was from Paxton, Illinois, and was employed by the railroad. He boarded the passenger train in Freeport on Saturday, December 14, and was reported as missing after the accident. Another man, William Hammond, was also missing. Hammond, an African American who worked for the water department of the Illinois Central, was not heard from for a few days after the accident. Both men were assumed killed in the crash but were later found alive. Charles Coffey from Dubuque also had a happy ending when he was able to contact his friends to let them know he was not injured.

Harry Wellman, twenty-four, who worked for the Illinois Central in the water division, was seriously injured and attracted the attention of many because he was scheduled to be married on Christmas Eve. His sweetheart, Maude M. Stuart from Chicago, described as very pretty, quickly rushed to his side. Doctors feared they would not be able to save young Harry and that Maude would be planning Harry's funeral instead of their wedding. However, he lived and she stayed with Harry for two years while he recovered. In August 1903, he received

a $12,000 settlement from Illinois Central Railroad. Harry and Maude were married in the fall of 1903.

The conductor on the passenger train, J.H. Quinlan, telegraphed his family that he was injured but alive. His wife could not wait any longer to see her husband and traveled to Rockford to be with him. Quinlan was forty-six years old at the time of the wreck and had worked for Illinois Central since he was fourteen years old.

None of the dead was from Rockford. They came from Chicago and Freeport. But the Rockford community's hearts went out to the families of the people who died in the crash. There was not much to be done for them. The families who were left behind all received yellow sheets of paper notifying them of the wreck and the deaths of their loved ones.

Richard W. Ormsby, the engineer on the passenger train, left his house at 4:30 p.m. He kissed his wife and daughter, Irene, goodbye and promised her that he would see Santa Claus and let him know what the little girl wanted for Christmas. Ormsby was one of the longest-running engineers for Illinois Central and was considered very careful and reliable. This accident was the first major one he was involved in.

Another man killed in the wreck, J.W. Funk, a brakeman, had lost his wife just two months before the accident and had taken a six-week vacation to settle his young son in with Funk's mother in Bloomington. He had just returned to work.

The blame was eventually laid on the engineer and conductor of the freight train. They were notified at their Hawthorne stop that the passenger train was running late, and they were to "take a siding" to give the passenger train the track.

The trains usually met every night at Coleman's station a few miles south of Elgin. When the trains were running on time, the freight train was on the siding there at around 8:23 p.m. It was the job of the freight train to figure which siding it could reach to wait for the passenger train. The telegraph lines were closed at night, so there was no way to check on the progress of the passenger train. Conductor Osten of Freeport was in charge of those calculations.

Osten worked around the wreck all during the night and then could not be located. Later, it was reported that he walked to Irene and then Cherry Valley, where he caught a train home to Freeport. Most of the witnesses at the inquest testified they believed that blame for the train wreck could not be accurately placed.

A total of thirteen men lost their lives that bitter December evening. This event stayed with the people of Rockford long after the debris was cleared. The newspapers carried stories of it on the anniversary date for years and recalled the personal experiences of those involved.

12
CAMP GRANT ACCIDENT OF 1925

C amp Grant was built in 1917, covered over five thousand acres, included over 1,100 buildings and at its height housed over fifty thousand men. It was used as a training center for cavalry, machine gunners, engineers and artillery personnel during World War I. After the war, the camp was used for a variety of purposes, including as a temporary training facility for the Illinois National Guard. In 1925, a very special training was planned, and the camp was expecting the largest number of soldiers since the end of World War I. Preparations for the huge encampment that took place in August 1925 had gone on for months. New mess halls and latrines were built, and other buildings were renovated. The Illinois National Guard Units were expected to meet and conduct maneuvers at the camp from August 15 through August 29. Over eight thousand men were expected at the camp during that period.

City officials and the National Guard were expecting big crowds for these practices. They had prepared for ten thousand visitors from all over northern Illinois. There was a variety of military maneuvers planned for the special training, including chemical warfare and artillery including howitzers and machine guns. All did not go according to plan.

On Sunday, August 24, 1925, the training was to include a chemical warfare demonstration in the afternoon. Hundreds of cars containing civilians lined the field to watch the demonstration of simulated battle maneuvers. The gunners were laying down a smokescreen for the line of infantry when a volley of phosphorous gas smoke grenades exploded and came down in the midst of the spectators' cars.

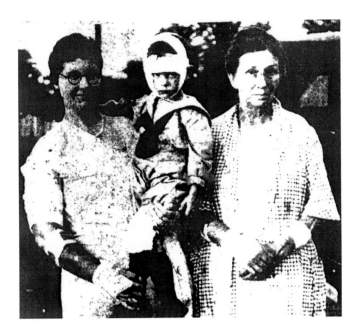

A photograph of victims of phosphorous rifle grenades. *From* Rockford Register Gazette.

"One of the bombs exploded right on top of a car owned by Gary Flanders. The bomb tore its way down through the car roof and exploded directly onto Flanders and the other people in the car. The smoke from the grenade was so thick that even cars around the Flanders' car were engulfed. The horrific scene was made worse by the sound of the children crying and screaming. Flanders exited his car and went running through the smoke with his clothing on fire. A soldier grabbed Flanders and threw him to the ground. The soldier rolled Flanders around until the flames were extinguished."

Another bomb hit the running board of John Anderson's car where his wife and three children sat. When the bomb exploded, it blew out the windshield and burned Anderson on his face and neck.

E.C. Hayes and his five-year-old son were injured when the boy's clothes caught on fire. E.C. ran to safety and then tore the child's clothes off. Unfortunately, the child suffered severe burns on his head, and his father's hands and arms were burned.

Camp ambulances rushed the injured to the camp hospital. Over seventeen people were injured from the grenades, mostly children. Over five thousand people were watching the military maneuvers on Sunday, and Major General Milton J. Foreman, commander of the

Thirty-third Division, promised a thorough investigation into the accident. The newspaper also mentioned that only those spectators who crossed the guard line had been injured.

The war games continued the next day to an even more horrific event. The Eighth Infantry unit was demonstrating a type of cannon called a howitzer when it exploded during the battle drills. The accident occurred on the gun range below the Camp Grant Bridge over the Rock River. There were fifty-five men in the unit, and thirty-eight of them were wounded. The Eighth Infantry unit was part of the Colored National Guard Regiment. Seven men from the Eighth Infantry were killed immediately, two more would die later and thirty-one other men were wounded.

A list of the dead:

- Captain Osseola A. Browning; Chicago, Illinois. He was the commander of the howitzer company. Osseola had both legs shattered and one torn off, and his chest was caved in.
- Corporal Henry Williams; Chicago, Illinois. He was in charge of the gun squad.
- Private Delmas Campbell; Chicago, Illinois.
- Private Herbert Durand; Chicago, Illinois.
- Private Benny Anderson; Chicago, Illinois.
- Private Charles Wright; Chicago, Illinois. Died at Swedish American Hospital at 1:30 p.m. His leg had been torn off, and he had a broken arm.
- Private Elmo Baynes; Chicago, Illinois. Twenty years old, he died at the Rockford Hospital at 2:25 p.m. on the operating table.
- Private Todd Moseley; Chicago, Illinois.

Several people were severely injured, including little Allan Williams, an eight-year-old boy who had his arm blown off. He was the nephew of Captain Browning and considered the "mascot" of the howitzer company. Little Alan was the only civilian near the howitzer when it exploded.

Medical units from the camp were sent immediately by Major General Milton Foreman. The injured men were brought to the camp hospital, and then the more severely wounded were delivered to Rockford's three hospitals.

Captain Osseola Browning was a war hero and the pride of his unit. He was a lieutenant in the 370th Infantry during World War I. He was awarded the Croix de Guerre for bravery in action by the French government.

Tragically, his wife had arrived in the camp to spend the day with her husband. She collapsed after hearing of the death of her husband and was rushed to the camp hospital.

Browning was born in Chicago on June 18, 1896. He graduated from Wendall Phillips High School in 1914 and went on to study chemistry at Northwestern University. He attended arsenal machine gun school at Fort Sam Houston in San Antonio, Texas, in 1916 and the Infantry School of Arms at Camp Logan in Houston. Browning went to the First Corps School in France and served there with distinction during World War I. Osseola took great pride in serving in the howitzer division.

Stanley Jones, department sergeant, was delivering a truckload of shells when the explosion took place. Jones heard Captain Browning order Corporal Williams to fire the mortar. Jones was hit with a deafening blast that knocked him down. The next thing he felt was the body of one of the men killed in the blast landing on top of him.

The bodies of the dead soldiers were transported to the Cavanaugh and Cannon Funeral rooms on South Court Street. Coroner Fred Olson did not conduct a civilian inquest but did attend the military one. The commander of the Eighth, Colonel Otis B. Duncan, arranged for a funeral service in Chicago at the Eighth's armory.

Witnesses described the scene: "The men of the ill-fated grouped about him [Colonel Browning] as he explained the workings of the instrument of death he was demonstrating. The load was inserted. The men stepped back a few paces, and Captain Browning ordered Corporal Williams to prepare to fire. Corporal Williams dropped shell into the mortar."

Huge chunks of metal flew through the air, tore off limbs and penetrated skin of stomachs and chests. The screams of the dying and wounded could be heard throughout the smoke-filled battlefield.

Another nephew of Captain Browning, Rush Smith, ran and walked the miles from the field to the camp to fall at the feet of Master Sergeant Leon Cornick to tell him of the tragedy. Leon swept the boy into his arms and carried him to his tent. Rush sobbed as he told the tale of his "Uncle Os" and the other men being blown "to pieces." Later, the scene between the little boy and the newly widowed wife of Osseola was heartbreaking to all who witnessed it.

A witness of the scene, Private James Hasty, came close to being another victim of the bombing. A piece of metal tore through his coat sleeve and imbedded in the canteen that hung at his side. The hole it ripped into the canteen was over two inches in diameter.

A memorial service was held for the men at Camp Grant. The newspapers called it "a sacred service to the memory of the victims of the worst disaster that has ever taken place in Camp Grant since its inauguration as an army cantonment."

Days later, a larger memorial service was held in the boxing ring of the Eighth Regiment in Chicago. Captain William S. Bradden spoke a moving eulogy to the men, both white and African American, who gathered to honor their fallen comrades.

Thirty-five thousand people jammed the Eighth Infantry armory for the memorial service on September 1. A unit was sent from Rockford. Buckbee Greenhouses designed a floral arrangement, and the citizens of Rockford donated money for the floral arrangement in a bucket drive. It was in the shape of a giant howitzer and would be delivered to the memorial service by the African American delegation. The arrangement was five feet tall, and the barrel was seven feet around and carried a sign that stated, "Sympathy from the Citizens of Rockford." It was made from red, white and blue flowers and weighed over 250 pounds. Major General Milton J. Foreman, commander of the Thirty-third Division, and Colonel Otis Duncan, commander of the Eighth Infantry, also attended the services.

Rockford judge Carpenter spoke for the 100,000 people from Winnebago County who sent their respects to the families of the dead men.

There was not a dry eye in the whole building when taps was played. The caskets were open as the families and friends filed past. The bodies were laid out in state under military guard Sunday night and were released to the families for burial the next day.

During the memorial service for the dead soldiers, other soldiers were still in Rockford hospitals fighting for their lives. One, Lieutenant F.G. Harris, had his abdomen punctured by a large piece of flying shrapnel and suffered a relapse at St. Anthony Hospital. His mother and his wife traveled to his bedside.

On September 12, the remainder of the seven wounded infantrymen were taken from Rockford hospitals and delivered to Chicago. First Lieutenant H.A. Callis of the Eighth Infantry Regiment, medical detachment, would accompany the soldiers back to Chicago. Fortunately, Allan Williams, the little eight-year-old mascot of the Eighth, survived and returned to his school.

Major General Milton J. Foreman stated in his tribute to the fallen soldiers, "Not alone on battlefields are heroes found." He emphasized the sacrifice that the eight men made while wearing the uniforms of the Illinois National Guard.

13
SUTTON TOP SHOP FIRE

Mildred Cramer was the twenty-year-old daughter of Mr. and Mrs. Fred Cramer, who lived at 410 South Fourth Street in May 1926. She was born in Cherry Valley, Illinois, and went to school there. Mildred moved with her parents to Rockford early in the spring of 1926.

Mildred was previously employed for four years at the H.W. Buckbee Florist Store on South Main Street but had just recently quit when some dirt that blew into her eye caused an infection. It was a frightening experience because the infection caused the loss of sight in her eye, and the doctors didn't know if it would be permanent or not. Eventually, the infection cleared, and her eyesight returned to normal. However, her parents were concerned for her safety, and it was decided she would find employment elsewhere.

Mildred was very excited to acquire a position at the Sutton Top Shop at 420 Elm Street. The building was once an old livery stable that had been converted into a "light" manufacturing business. This was a small shop that manufactured and repaired winter covers for all makes of automobiles, performed automobile body repairs and made celluloid sun visors for adults and children. Brothers William and John C. Sutton owned it. A heavy demand for their product made the owners decide to expand to forty-eight people who would work two shifts. They were even planning to move to a new building. The brothers were hoping to be up to full speed by the following week. Mildred was hired to work the second shift. She had been there for two days and liked the work so far. Mildred was especially thrilled

A photograph of Mildred Cramer, killed in the fire, 1926. *From* Rockford Morning Star.

because they were bringing two new women in to train, and she was excited about meeting them.

Friday, May 28, started out with its usual routine. Mildred had been at work for about half an hour. She had already been introduced to the new girls. There were about sixteen other girls on the second floor working on different projects. The second floor was where the cloth part of the roofs was sewn to the celluloid parts. It was approximately 4:30 p.m.

There were a few men working on the first floor. Two of the men were cutting the celluloid with a band saw. They didn't notice the electric charge that built up or see the sparks that floated down to the floor, but then some of the sparks landed in a pile of celluloid on the floor and ignited it. The workroom was directly under the stairway to the second floor. Intense black smoke billowed up the stairway and was followed by an explosion as the celluloid was engulfed in flames.

The men on the first floor desperately tried to extinguish the fire but, within a minute, the flames had spread all over the room. The men had to flee to save their own lives and abandon the women to their fate. The room caught fire like a pile of dry sticks.

Their only exit was now blocked by thick smoke, and the flames were spreading very fast as the celluloid quickly ignited more of the material. The room instantly filled with flames. One survivor said they had about two minutes to decide whether it would be safe to jump out of the window or stay inside. The scene was mass confusion as the black smoke blinded the girls, and the screams were intense as the fire grew. The women fought their way through the room, falling over one another and the machines in a blind dash to the windows. One woman, Leone Lowling, recalled the horrible scene:

"We hardly had time to leave our workbenches, the flames were shooting up all around us." Leone was one of the first women to leap from the second-story windows to the street below.

Another survivor, Elsie Baker, stated, "We had no time to think of what to do." Elsie was trapped in the back part of the room and made it to safety by dashing out of a window on the east side of the building and running across the roof to a store located next door.

One woman, later labeled the hero of the day, was Lillian Finkbeiner, the sister of Mrs. William Sutton. She led four of the girls to safety through a window onto the roof. She broke a window out in the Patton Hardware building to gain access. Lillian was glad she was able to save the four but felt that she should have gotten more of the girls out.

The first unit of firefighters arrived from Central Station, which was located just around the corner on Church Street. Some of the men attempted to quickly get water on the building, which was billowing great clouds of black smoke. Other men attempted to assist the workers who were fleeing the building. Fire chief John D. Blake would later be commended with the other firemen for doing a wonderful job protecting the adjoining buildings from burning. Six firemen were injured as they attempted to reach the women trapped in the fire.

People lined the street, and pictures from the day show some with arms reaching out as if to catch the women. Two men who worked at an adjoining garage, Bud Shields and Sam Weinberg, tried to break the girls' falls. One girl whose clothes were smoldering jumped into a car and set the upholstery on fire. The men put out the flames by rolling the girl on the cement.

The owners, John C. and William, kept rushing back into the building to try to save more women until the fireman finally forced them to stop.

Five women died immediately, and Mildred was one of them. These five were in the center of the second floor and never stood a chance. The celluloid went up like gasoline had been poured over it, and they were overcome by the flames. Two of the dead women had only been in the building for half an hour.

Eight other women were sent to the hospital, some with horrible burns. One girl, seventeen-year-old Lillian Steffen, landed on a truck when she leapt from the building, breaking her back and arm. Originally, it was thought she would not survive, but Lillian made a full recovery and was released from the hospital on June 30.

There was a huge crowd gathered outside, and the newspaper reported that when the firemen could finally enter the building to remove the bodies,

the crowd was amazingly silent. Family members desperately tried to push their way to the front to see if their daughters or wives were among the dead, but they were restrained by policemen. Fred C. Olson, the coroner, went in to help remove the bodies. He personally wrapped each girl in a tarp and had the firemen carry them to the morgue wagon using the alley. The wagon left fifteen minutes later "and wove its way through the silent mass of humanity."

Mary Lillie, thirty-six years old, was born in Monrovia, California, on June 10, 1889, a daughter of Mr. and Mrs. William Ashton. Mary moved to Rockford in 1905 and married Oran Lillie in 1906. Oran worked at the Mechanics Machine Company. They had eight children—Sherwood, sixteen; Lois, fourteen; Clifford, twelve; Avis, ten; Wilma, nine; Alvin, seven; Dawn, five; and Hazel, who was just three at the time of her mother's death. Mary Lillie was buried at Greenwood Cemetery.

Helen Mamalis was a native of Greece who came to Rockford in 1914. Her husband passed away eight years prior to the fire, and the family had struggled since his death. Helen had been ill for several years and had recently returned from a stay in the Elgin State Hospital. Since the children were so young, Helen qualified for the mother's pension fund, but the twenty-five-dollar sum did not go very far. Her eldest son, Theodore, worked part-time at the Louis Café on West State Street. The fifteen dollars a week helped, but Helen was forced to seek other employment. Her other children George and Mary were students at Roosevelt Junior High, and the youngest, Aphrodite, attended classes at Blake School. The job at Sutton's seemed like the answer to a prayer. Tragically, the children were left orphans by their mother's death in the fire. Their father's brother, Peter, was not able to keep them together. Arrangements were made for a service for Helen at the Greek Orthodox Church and for burial at Greenwood Cemetery.

Mary Walleck came to Rockford in the middle of May 1926 to look for employment and to visit her aunt, Mrs. John Kubelas, who lived at 913 Rockton Avenue. She was from Kansas City, Kansas, where she lived with her mother. Mary discussed applying for the job at Sutton but changed her mind when she saw it was originally a third-shift position. When Mary saw another advertisement for the second shift, she applied for a position. She was hired the day before the fire and showed up for her first shift just a few minutes before the fire broke out. Mary was only twenty-one years old.

Minnie Stromdahl was twenty-seven years old and was the daughter of Mr. and Mrs. G.T. Huffman. She was married to Emil Stromdahl, and they moved to Rockford in March 1926 from Centerville, Iowa. Emil worked

at the Skandia Lumber Company, and they lived at 716 Seminary Street. Minnie was working at the J.L. Clark Company until Tuesday, May 23, when she and several other workers were laid off. Minnie, like Mary Walleck, had only been in the building for a few minutes prior to the fire. She left behind a four-year-old daughter, Virginia. Minnie's body was returned to Centerville, Iowa, for burial.

The dead women were so severely burned that the flesh on their arms and legs burst open and made identification extremely difficult. Mildred's father came with her uncle and viewed the body four times and studied her features for over an hour before they agreed it was her. Helen Mamalis's body could only be identified by the jewelry that she wore.

A coroner's jury demanded that State's Attorney William Knight investigate the case further to identify whether there was any criminal negligence by Sutton Top Shop in the cause of the fire. There was another investigation launched by the deputy state fire marshal, George Kirane, who had inspected the Sutton Top Shop twelve months before the fire. At the time of the inspection, there were no women employed by the shop. Kirane had ordered certain changes to be made to the building to increase the safety of the workers employed there.

The cost of the damage to the building was listed between $15,000 and $20,000. The city started a fund for the care of the children left behind.

Fred Cramer later sued the company for the sum of $1,650 for the death of his daughter Mildred and was awarded the money by Arbitrator C.A. Townsend, who represented the Illinois Industrial Commission.

The Sutton Top Shop reopened in a new location at the corner of Chestnut and South Winnebago Streets in the fall of 1926. The new building included three new floors and cost almost $100,000 to build. The business was expanded to include visors for doll babies and shoes for children. The Sutton Top Shop still manufactured the winter tops for automobiles, but the new shop concentrated more on bodywork of wrecked vehicles. It eventually became one of the biggest body shops in northern Illinois.

John C. Sutton's words were echoed by the whole city: "I am overcome by grief. I will do everything in my power to aid those in need and to lessen the sorrow of relatives and friends of the dead, especially the children."

14
TORNADO OF 1928

The tornado that touched down on Friday, September 14, 1928, came in like a roaring train, leaving a path of destruction across Rockford. First, it touched down at the Rockford Chair and Furniture Company on the southwest side, at the intersection of Peoples Avenue and Kishwaukee Street, destroying the building and killing six men.

The funnel went back up and damaged poles and trees until it touched the earth again at Eighteenth Avenue and Eighth Street, where the Mechanic Machine Company suffered broken windows. The twenty girls who worked at the plant that day were cut from the flying glass but were otherwise unhurt.

The last section heavily hit was the Elco Tool Company, the National Chair Company and the surrounding neighborhood, where houses were wiped from their foundations. It was on Eighteenth Avenue that the three-story Union Furniture Company was destroyed. On the same corner, a little neighborhood grocery store owned by Cy Johnson and his wife was spun around several times and finally swept off its foundation. "We huddled behind the counter while the roaring noise was going on and the wooden benches flew over our heads." said the Johnsons, who escaped with just a few scratches.

Along Fifteenth Avenue, seven houses and their garages were knocked down. The northeast corner of the National Chair Factory was completely demolished as the tornado's devastation continued. Houses at the top of the hill of the Rock View neighborhood were untouched, but the hollow to the north was demolished. Nineteen houses on Nineteenth Avenue and Ninth Street were destroyed in the final fury of the twister.

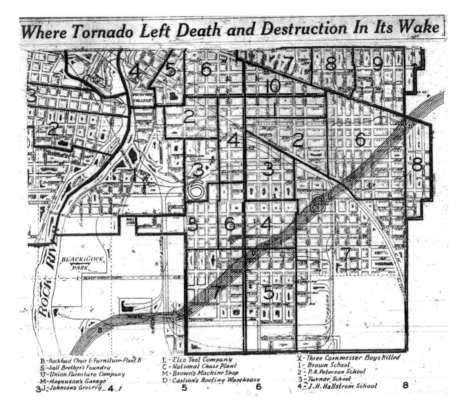

Where Tornado Left Death and Destruction In Its Wake

B - Rockford Chair & Furniture Plant B
S - Sail Brothers Foundry
U - Union Furniture Company
M - Magnuson's Garage
3 J - Johnson's Grocery 4 . 1

E - Elco Tool Company
C - National Chair Plant
M - Brown's Machine Shop
D - Carlson's Roofing Warehouse
5

X - Three Cornmesser Boys Killed
1 - Brown School
2 - P. A. Peterson School
3 - Turner School
4 - J. H. Hallstrom School 8

A map depicting the path of destruction from the tornado. *From* Rockford Morning Star.

A miracle took place in a house on Eighteenth Avenue that belonged to the Ebarp family. Little two-and-a-half-year-old Donald was sleeping in his crib when the tornado tore its way through the neighborhood. The wind uprooted a huge tree that stood next to the house and slammed it down on the roof. It knocked the chimney and the wall right down on Donald in the rear bedroom.

Mrs. Ebarp was in the basement with her daughter, and Mr. Ebarp was sleeping in another bedroom of the house. Mr. Ebarp was the first to reach the boy, and Mrs. Ebarp entered the room to find her husband tossing bricks, branches and boards off their smallest child. The father was terrified when he first saw his son's face covered in blood but he realized soon that the boy, while cut, was not seriously hurt. The family stood in the wreckage of their home and realized how fortunate they were.

The city was also grateful that even though the tornado came within a half a block of one school and very close to two others, the thousands

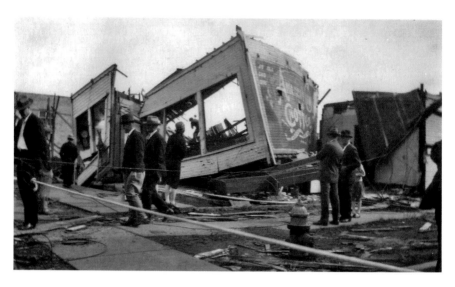

A photograph showing men assessing the damage from tornado. *From Midway Village Museum, Rockford, Illinois.*

of children who attended the schools were unhurt. Brown, Turner and especially Hallstrom School students and their families were feeling blessed. A mere half block down from Hallstrom School was a scene of terrible devastation. Houses all around the school had their roofs torn off and their windows completely blown out. Furniture was deposited in the streets, and trees were blown over. The four hundred students who attended Hallstrom were all kept safely inside the building.

Tony Martinkas, fifty, was found dead in a chicken coop on a farm on Harrison Avenue, four blocks west of Kishwaukee. He was from Spring Valley and was cleaning up the chicken and pigeon yard at a neighbor's home. Tony was busy working between two buildings and did not notice the tornado approaching. The wind slammed the poor man between the two buildings before moving on to the Chair Factory B, where it killed eight more men.

George Palmer, employed at the Mattison Machine Works, was one of the very first men to reach the destroyed Chair Factory B. He was stunned by the devastation but hurriedly grabbed an axe and started to chop his way into the building. He was able to bring three men out before others came to help.

The first wave of responders was firemen and policemen who walked through the destroyed buildings calling out for some sign of where the

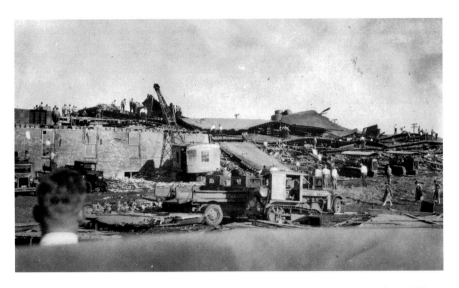

A photograph showing machines removing debris from a fallen factory. *From Midway Village Museum, Rockford, Illinois.*

survivors might be. Their calls went unanswered. They attempted to start removing the debris, but it was too heavy.

O.W. Johnson worked as the superintendent of the Chair Factory B and was buried in the debris from the storm. He was trapped under heavy timbers for three hours before his son heard his calls and found men to help focus on the rescue. He was rushed to Swedish American Hospital.

Building companies were contacted, and in an amazingly short time, the pleas for help were answered. Mayor Burt M. Allen, police chief A.E. Bargren and Sheriff Harry Baldwin, working with fire chief Thomas Blake and Captain Warren Aldrich of Company K of the National Guard, organized rescue efforts. This was the biggest response to a rescue operation ever in the history of the city. "Scores of contractors and factory officials, unaffected by the storm, offered the officials of the Rockford Furniture and Chair Company, trucks, men, steam shovels, hoists, and other equipment yesterday in a frantic search to find the bodies of the missing men."

State police officers arrived to assist deputy sheriffs, police officers and soldiers involved in organizing equipment, handling traffic flow and gathering information about the missing men. They also helped with crowd control, as thousands of people rushed to the factory. Ropes and men kept the crowd under control for the two days of searching.

More than two hundred men from the city's and county's building firms were involved in the rescue effort at the Chair Factory B. They all knew they were looking for bodies. When a body was located, all work would cease, and everyone silently watched as the mangled bodies were tenderly wrapped in a blanket, loaded on a stretcher and carried to an ambulance.

Forrest Lydden, a city building inspector, organized the crews. Tireless searching went on for two days. They recovered the body of Gunnar Ryden at 1:40 a.m. on September 17. He was killed on his twenty-ninth birthday.

The other men who were killed in Chair factory B were:

- Olaf Larson, twenty-seven years old
- Herman Wydell, forty-seven years old; left a wife and two children
- Martin Anderson, thirty-four years old; left a wife
- August Peterson, fifty-two years old
- Frank Strom, thirty-four years old; left a wife and a child

All six of the bodies were found near the elevator shaft, close to the heavy water tank, which plunged from the roof through the crumbling floors, crushing the men and causing their deaths. All of the men were working in the finishing department on the second floor when the tornado struck. John Brunski, forty-five years old, and George Fagerberg, fifty-one years old, were the two other victims in the plant.

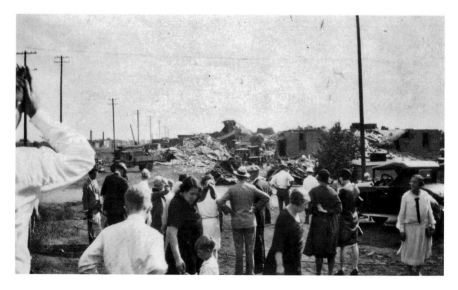

A photograph of another damaged factory. *From Midway Village Museum, Rockford, Illinois.*

MAYHEM

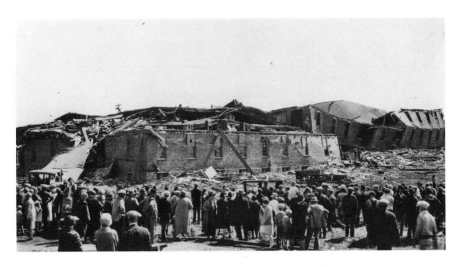

A photograph of the damage at the chair factory. *From Midway Village Museum, Rockford, Illinois.*

Other men working at the Chair Factory B were up on the fourth floor when they heard yelling that a cyclone was approaching the building. The group started to run down the stairs when the funnel hit the building, right in the area where they were. The men were all piled on top of one another, and everything was completely dark. They were trapped for several hours before being pulled from the debris.

The Union Furniture Company's east end was demolished, adding to the city's death toll. Swan Swenson, forty years old, and Axel Ahlgren, forty-three years old, were found beneath the wreckage of the water tank. Ahlgren's body was carried all the way down through the building by the water tank and buried under tons of debris. The men trying to rescue him had to cut their way through the shattered timbers of several floors.

Seventeen-year-old Virgil Cornmesser, sixteen-year-old Everitt Cornmesser and fourteen-year-old Bernard Cornmesser were sent to a nearby gas station to buy a gallon of gas. The boys noticed the approaching storm and were racing to their homes before it hit. They reached the corner of Seventh Street and Seventeenth Avenue when, suddenly, an entire garage roof was blown off and came down right on top of them. Everett and Bernard were killed instantly, and Virgil died later at St. Anthony's Hospital. The family held a triple service for the boys in the home of S.O. Cornmesser at 1728 Seventh Street on Sunday, September 16, with Reverend O. Garfield Beckstrand officiating. Virgil and Bernard were brothers and the sons of

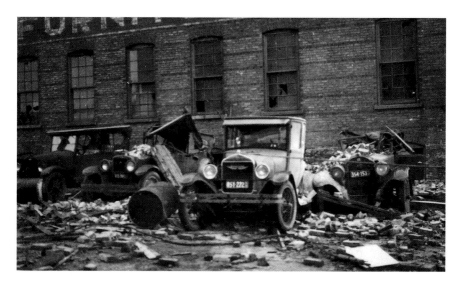

A photograph of cars damaged by debris at furniture factory. *From Midway Village Museum, Rockford, Illinois.*

Mr. and Mrs. John Cornmesser. Everitt was their cousin, and his parents were Mr. and Mrs. S.O. Cornmesser. Virgil and Bernard's parents shipped the boys' bodies back to Iowa with the help of some of the tornado funds donated by the city, and Everitt was buried in Rockford.

A blinding rain started to fall right after the funnel hit the area, and ambulance drivers had trouble getting to the boys quickly because of the rain and debris that lined the streets. They loaded all three of the boys into an ambulance.

All of the other bodies were taken to the undertaking rooms of Fred C. Olson. Family members gathered there, anxiously waiting for some word on their missing men. Piercing cries were the notification that another man had been identified and another family's hope shattered.

Besides the fourteen men killed, there were over 80 people injured that needed hospitalization. Over 360 buildings, 181 of them houses, were damaged, costing over $1,000,000. There were 1,200 people left homeless, and because most of them worked in the same neighborhood where they lived, they had also lost their place of employment. These families were in dire need of assistance.

The Rockford Chamber of Commerce kept busy collecting donations for the families of the men who were killed in the tornado and other families left homeless by the storm. The money just came pouring in, and the chamber was able to gather $25,000 in a very short time.

MAYHEM

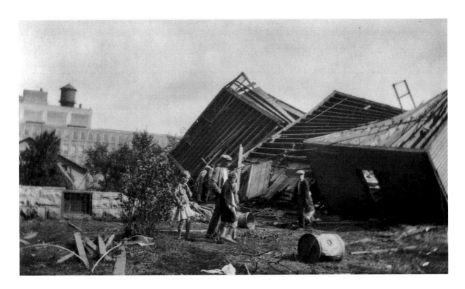

A photograph of a family who lost their home in the tornado. *From Midway Village Museum, Rockford, Illinois.*

Committee members from several different organizations visited over 164 families to assess their needs and determine how to fund them. Agencies, including the *Rockford Register* newspaper, were busy collecting funds as well. The Red Cross was working with the other agencies to go into the affected area and assess the property damage. Wilbur J. Adams was the director of storm relief and in charge of getting the needed supplies to the people.

On Sunday, September 16, people from all over the state came to visit Rockford to view the damage. Estimates put the number somewhere near 150,000 people who came to town on that Sunday following the tornado. They surged into the area and stopped at local restaurants to eat. By the end of the day, most of the restaurants were running out of food. One estimate put the total served at 60,000. Some of the people were family members who came to help, and police and other rescue workers were very impressed with the crowds. There were issues with traffic, but everything stayed orderly. There was no looting or destruction caused by the visitors.

The theaters in town donated half of their proceeds on different days toward the relief fund. The Palace Theater showed motion pictures of the destruction during the Pathe newsreel. It featured three hundred feet of film highlighting the damaged areas.

Rockford has always been known for stepping forward during times of need, and this crisis was a perfect example of that. Many in the community

gave selflessly of either their time or money, even those who were themselves in dire straits.

Fred Machesney, manager of the Rockford Airport, gave a percentage of the proceeds of his sales for transporting passengers to the relief fund. The Women's Society, headed by Jessie Spafford as its president, visited damaged homes and brought much-needed supplies. The Rockford Girls served donated food and drinks to the searchers and men working on the rescue efforts at the factories; Boy Scouts helped to maintain a line of safety for visitors and family members at different locations. E.A. Brodine, secretary of the local carpenters union, reported that local carpenters would be gathered to help with repairs on damaged homes. It was an incredible outpouring from everyone, and Mayor Allen was very proud that his city was able to care for its own without assistance from outside agencies.

The city bounced back, and even before the first night was done, plans were being made to rebuild the factories. Aid was given to the neediest families, homes were repaired and families were reunited. Because of the tireless searching by the men and donation of equipment by various companies, every body was recovered quickly. The families who lost their men were given extra aid to rebuild their homes. The community responded so quickly and so generously that many of the families felt grateful that they lived in such a caring community when disaster struck.

15

PROHIBITION: THE EARLY YEARS

1920–1923

Why don't they pass a Constitutional Amendment prohibiting anyone from learning anything? If it works as well as prohibition did, in five years, Americans would be the smartest race of people on the earth!
—Will Rogers

There are certain images that cross your mind when you hear the word "prohibition." One might be sharp-dressed men driving fancy cars; the other might be wild parties with bob-haired women dressed in flapper-style dresses dancing their cares away as the bathtub gin flows. A darker image might be of the gangsters from that period, driving by and shooting their guns at people on the street or police raiding homes and breaking up stills, emptying bottles of moonshine into the street.

There are also stories of everyday folks getting very sick drinking what they thought was homemade moonshine but turned out to be poison. The federal government passed a law that methanol be added to all industrial alcohol to discourage consumption during prohibition. Methanol is a poison that causes blindness and even death. In July 1920, two soldiers from Camp Grant, Private George Girex and Luther H. Davis, were admitted to the base hospital after consuming denatured alcohol.

Girex was in serious condition when checked into the hospital. He was blind and very confused. He was with a group of friends from Camp Grant on West State Street at the Loop Café when he passed out. Fortunately, both soldiers made a full recovery. Girex was the one who

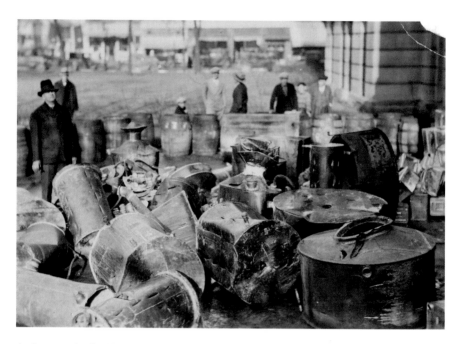

A photograph of police dumping confiscated illegal liquor in the street in front of the courthouse. *From Midway Village Museum, Rockford, Illinois.*

brought the liquor in a small bottle. At first, the doctors thought he drank the poison in a suicide attempt. His fellow soldiers told the doctors the truth, and eventually it was all explained.

During the period of 1920–33, there was a battle of sorts happening in the streets of Rockford. Sometimes the battle was between the police and the bootleggers. Other times, it was bootlegger against bootlegger as different gangs fought for the advantage in the selling of illegal liquor. There were smaller battles as the liquor makers stole from one another. They would break into houses, stealing equipment, mash or the bottled liquor from one another.

One of the first "kings" to be caught was Stanley "Big Steve" Makeshaitis, a Lithuanian who ran at least five different stills and was suspected of running even more. He pleaded guilty to making, transporting and selling moonshine. He was fined $1,000 and served sixty days for perjury and bootlegging.

The newspapers were filled with stories of the raids that the police held on different houses where the booze was made or the speakeasies where it was sold. People would remodel their homes to hide the booze under trapdoors and in closets. Other bootleggers were even more clever. One man became famous throughout southern Wisconsin and northern Illinois when he shared his secret of smuggling booze in chicken eggs. He blew out the contents of the eggs, filled

them with liquor and sealed the holes with candle wax. His house was raided several times, but the police never found any of the hooch. He loved to tell the story of the police tearing apart his house while he sat at the kitchen table right by a basket of freshly gathered eggs. His secret was discovered when he offered to sell it to the wrong man, who later used it as a bargaining chip with the police.

The liquor business was an equal-opportunity employer. Men and women—white, African American or Native American—were all represented in the jails in the beginning. Whole families became involved as people struggled to hold jobs and feed their families.

Claims of illegal hooch being dangerous were proven in 1922 when Jeremiah Mutimer, a well-loved local man, bought illegal hooch and died shortly afterward. Mutimer, forty-three years old, was going on a trip to California and left the house to buy his ticket. "I think I will go out and get a couple of shots of hooch for my California trip," he told his niece before leaving the house.

When he returned around 5:00 p.m., he seemed slightly intoxicated and had no ticket. He pulled the bottle from his pocket and drained the remainder of the liquor. As he finished the bottle, he collapsed. His family thought he was just intoxicated and carried him to bed.

In the morning, his niece's eight-year-old son, Joe, who was Mutimer's constant companion, tried to wake him up. Joe was unsuccessful and ran to get his mother. It was then that the family realized that Mutimer was dead. The coroner, Fred C. Olson, was sent for. Olson questioned the family and learned that Mutimer had been drinking. Little Joe told police and the coroner that Mutimer frequently purchased his booze from Big Mary.

Police were very familiar with Big Mary. Her full name was Mary Bukowski, and she was known to the police, the state's attorney and the people on the southwest side of Rockford. Little Joe accompanied his great uncle to Mary's place many times in the past to buy the illegal hooch. In fact, on the last trip, just two days before Mutimer's death, Big Mary had threatened Joe and told him not to return.

The county physician, Clarence Boswell, conducted an autopsy on Mutimer and sent the contents of his stomach to Kenneth Jones, the city chemist, to see if he could determine what ingredients were used to make the booze. This would allow them to determine which liquor maker had mixed the lethal dose.

Jeremiah worked as a knitter at the Burson Knitting Company in the past but had quit his job to move to California. He was home for a month-long visit with his family and staying at his niece's house. The family told the police that Jeremiah was a well-known man with lots of friends. His only

problems arose from his drinking habit. It had increased in the last year, and his family was concerned for him.

Jeremiah's death was later determined to be caused by the swelling of his brain due to the poison contained in the illegal liquor. Big Mary and her son, Sigmund, were both arrested and later released on bond. It was decided that the poisoning was accidental.

Rockford earned a reputation for being so strict on bootleggers that the supply of hooch was in high demand. In 1922, bootleggers would come from all over Illinois to attempt to sell illegal liquor at higher prices than they could charge in other areas. This kept the police busy with the increased liquor traffic and with the skirmishes that erupted between the local dealers and the visiting booze sellers.

The bootleggers started to organize into gangs in 1923. The *Rockford Sunday Republic* dated August 17, 1930, stated the reason for this was "to withstand the attacks being made on them by enforcement officers, and to hold up the tumbling alcohol and moonshine prices which were rapidly slipping down."

The gangs had to use strong-arm tactics to ensure their success. The first reported gangland killing in Rockford was on October 8, 1923. George Minert, thirteen years old, was looking for insects for his zoology class on the Fred Stoner property on the Old Freeport Road that branched off of Montague Road almost four miles southwest of Rockford. Minert must have been horrified when he looked into a culvert and found a body. The man was later identified as Louis J. Milani. Milani had his head bashed in, and his throat was cut ear to ear so deeply that he was almost decapitated. He had deep slashes on his face and hands. A large one-hundred-pound rock had been placed on his chest, and then his body was stuffed into the culvert. The police believed that Milani was grabbed from his rooming house at 412 Sixteenth Avenue, knocked unconscious and then taken outside the city. The evidence proved that he was already in the culvert when his throat was cut.

Police knew that Milani worked in the "bootleg racket." They worked the theory that Milani had been "taken for a ride" by the gang for an unknown reason. They hit a brick wall in their investigation, and the murder went unsolved.

Coroner Olson was approached by a medical school in Chicago. They requested Milani's body for teaching purposes. Olson decided that the body should stay in Rockford, in case family turned up at a later date. Louis Milani was laid to rest in the Potter's Field in at the Winnebago County Poor Farm Cemetery.

16
PROHIBITION: SNOOPERS AND SPOTTERS

1923–1928

Prohibition was a dangerous time in Rockford's history. Police conducted raids on houses and speakeasies, seeming to be always one step behind the rumrunners. By 1923, the police were desperately trying to catch up. They developed undercover men called "snoopers" and "spotters." These men worked from the inside of the bootlegger business and reported back to the police on the makers and the sellers of the illegal liquids. Rival gangs also employed snoopers to gain inside knowledge of the other gangs' activities.

But these undercover operators had a terrible side effect. When these men started reporting what they found, the gangs retaliated with gunfire. The first incident occurred on the corner of South Main and Morgan Streets. This area of Rockford was the center for the illegal activity associated with these gangs.

One of the first suspected victims was nineteen-year-old Adam Lingus. Lingus lived on South Winnebago Street and was known in the neighborhood for his disfigured face. He had a noticeable scar and a hair lip that made him very self-conscious. Lingus was a ward of the state when his parents forced him to leave their house. Phillip Oddo owned a café called Oddo Inn at 219 Morgan Street and supposedly helped Lingus by feeding him. On December 30, 1923, Oddo shot Lingus. Lingus lived for a while after the shooting and gave conflicting stories to the police. Phillip Oddo first claimed that an unidentified drunk man shot Lingus. Then after hours of intense questioning by the police, Oddo stated the shooting was an accident. He was cleaning the gun in the kitchen, and it discharged and hit Lingus in the side.

The .38-caliber bullet entered into his right side and passed through both of his lungs.

The police suspected they had the actual shooter in Oddo. What they could not discern was the motive. There was no known argument between the men, no love triangle and no jealousy issues. They could not find that any reason for Oddo to shoot Adam Lingus. Phillip Oddo was acquitted, and he went back to running his café. He was arrested numerous times over the years for selling illegal liquor. A newspaper article from 1930 suggested that Adam Lingus was a spotter for the police and that Oddo had discovered this and shot him.

In 1925, there was another bad batch of hooch that circulated, but this time, the effects were worse than just making people sick. Near the Chicago, Milwaukee and St. Paul Railroad line, there was a sand house that was a popular hangout for hobos and transients near Kent Creek. Two of the men who rendezvoused there were John Wickler and William Waller. These men were old friends, and they had been unemployed for a while by November 1925. Apparently, the men had made a visit to their favorite bootlegger on November 4. Neither of the men could know that it would be their last. Police found John Wickler not far from the sand house around three o'clock that cold afternoon. Wickler was staggering around, and police initially thought he was intoxicated, so they took him to jail to sober up. Wickler started having seizures and died in his cell.

A short time later, an anonymous person called in a tip that there was a body inside the sand house near the railroad line. The police went to investigate and found William Waller inside. He was obviously dead, and the appearance of his body led officers to believe that he had been so for several hours. Despite an intense investigation, the makers of the poisonous liquor were never found.

Authorities in Rockford decided to go all out on for the "Make Rockford Dry by Christmas" campaign. The police department and the sheriff's office combined forces and held a succession of raids of houses and known speakeasies. On December 2, authorities raided ten houses and arrested two men and two women. Police, working with spotters from Chicago, had gathered evidence for weeks until they had enough to act. Mr. and Mrs. Choppi of 144 Fourteenth Avenue, John Castree of 1224 South Main Street and Mary Pushca of 7 Magnolia Street were all arrested on charges of selling liquor. They pleaded guilty and were fined $1,000 each. During the raid, over one thousand gallons of wine plus three dozen bottles of beer were found at the Choppi house.

MAYHEM

On the same day as the other raids, federal agents, working independently from the local authorities, raided the warehouse and then the home of William D'Agostin at 208 Fifteenth Avenue. First, the federals swooped down on the D'Agostin Soft Drink warehouse at 324 North Madison Street and collected eight hundred gallons of alcohol. Then they proceeded to the D'Agostin home, cut the telephone wires and arrested D'Agostin. Within fifteen minutes, the agents had taken D'Agostin into custody and confiscated seventy gallons of liquor. The Rockford Police Department, the Winnebago Sheriff's Office and even State's Attorney William D. Knight had no idea the raid was going to take place. The federal agents were in Rockford less than two hours for the whole process.

Some of the leaders of the bootlegging gangs met to discuss joining forces to protect themselves against the raids. But as sometimes happens, one party thought another party wanted too much of the pie and negotiations literally exploded into gunfire.

This time, it was the attempted murder of police spotters David Dotz, twenty-three, and his eighteen-year-old brother, Alex, on September 22, 1926. The Dotz brothers were called spotters deluxe because of the number of bootleggers they reported on.

The boys were leaving their house at 905 Sixth Avenue and climbing into their vehicle when they noticed a large sedan approaching. The four men in the passing car opened fire with their shotguns, and as a result, David was injured in his eye. He would later lose sight in this eye because of the wound. Alex was grazed in the head and took a full hit to his shoulder that broke his scapula. The car continued down Fifth Street toward Keith Creek, turned west onto Eighth Avenue and then onto Kishwaukee

A photograph of David Dotz, a police informant during Prohibition. *From* Rockford Daily Republic.

A photograph of David Dotz's car after the shooting. *From* Rockford
Daily Republic.

Street, where it was lost in traffic. Police found one of the firearms in a creek
a few blocks down the street from the Dotz home.

Later, State's Attorney Knight took David to a garage where a car
matching the description was found. David identified the car and told the
police that he recognized Phillip Caltagerone, George Saladino and Tom
DiGiovanni as the shooters.

The next spring, the three men were put on trial for the attempted murder
of Alex Dotz. The trial lasted fifteen days and ended in an acquittal for the
men. It was described in the newspaper: "The trial of the three defendants
was one of the most sensational and long drawn out criminal trials in the
legal history of Winnebago County."

After the trial, State's Attorney Knight was quoted, "I have seen the signs
of this growing boldness for some time and this shooting is what I've been
expecting. It is time the people of Rockford awoke to the bootleg menace

here. The time has come to choose to decide whether it will become another Cicero or Canton."

The Dotz brothers were so frightened by the attack that they not only left Rockford but also Illinois and moved to Kenosha, Wisconsin. Later, they would be arrested for a robbery that occurred at the Kenosha Theater in which $1,000 was taken. The Dotz boys claimed they were framed. It was a hard fall for the once-legendary spotters.

On January 30, 1928, Larry McGill, a twenty-three-year-old watchman at the Joseph Behr junkyard, was shot. He was with a couple of friends in a Behr Company truck at a house on the corner of Keefe and Fifteenth Avenues. His companions were William Oberg and Joseph Kranski, both seventeen years old. The house that Larry was observing that evening was owned by Joseph Choppi.

As he lay dying, Larry McGill testified to Assistant State's Attorney Karl Williams and Robert Nash at Rockford Hospital. Later, he would tell police that he was just curious and decided to watch the house. There was a betrothal party going on at the house, and McGill wanted to see who attended. The other two boys' stories matched McGill's.

According to Larry, two men and a woman left the house. One man, dressed in a long fur coat, spotted Larry and his companions sitting in the truck. The man approached the pickup truck, yelled profanity, slapped one of the men with McGill and then shot McGill. McGill told police that Vince "Big Jim" Diverno shot him. Diverno was known to police as a "rum runner, racketeer, and a general bad character." He had also been questioned in Freeport as a suspect in other shooting and stabbing assaults.

Diverno owned a grocery store in Freeport, and police from both Rockford and Freeport searched for him. They followed tips in several different cities, and there were reports that police met with Diverno's wife to work out a possible surrender. But it was all in vain, and authorities never found Diverno.

Police suspected that Larry was working undercover as a spotter for one of the local gangs, and his cover was blown when he got careless. They did not believe his story of just being curious about the partygoers.

Coroner Fred Olson searched for family members to claim McGill's body and had just about given up hope when McGill's estranged wife appeared. She made arrangements for Larry's body to be shipped to Cherry, Illinois, where she lived with their young son. Mrs. McGill promised Coroner Olson that she would bury Larry like "his parents would have wanted."

Less than a week later, another murder, this one even more violent, took place. Tom Perra, thirty-five years old, also known as Redda, was once in

the bootlegging business. He lived at 726 South Winnebago with his family. During the first week of January 1928, all of Perra's bootlegging equipment was confiscated by the boss of one of the local gangs. A couple of days later, he decided to approach the police to offer to become a spotter for them. He was assigned to a partner who was working in Freeport. Perra moved his family to a new home at 810 Houghton Street on January 30, 1928. Later that day, he left the house, and his family never saw him alive again.

Perra went missing on Tuesday, January 30, but evidence showed he had only been dead a couple of days when he was found on Tuesday, February 6, 1928. Perra was the first Italian to turn into a spotter, and the man who worked with Perra in Freeport said that Perra was very spooked by the whole idea.

Perra's body was found around 9:00 a.m. on February 6 by Ben Olsen, a farmer who lived near Cherry Valley. Olsen was headed into New Milford with his wagon when he made the gruesome discovery. Perra was found in the woods off Perryville Road "by the old rifle range," one mile east of New Milford.

Perra was lying on his left side about fifty yards east of the road in the wagon ruts that lead through the woods. He had been shot in the head four times, and blood covered his face. The bullets had entered the back of Perra's head on the right side and exited on the left side of the forehead. He had his arms up in front of him as if he was trying to protect his head. The gun used for the killing was found a short distance away from the body.

Another farmer, Frank Carlson, told police he heard several shots on Sunday morning. He did not report the gunfire because he thought it might be a hunter. Another farmer who lived in the area said he noticed cars coming and going in the woods, but that was usual for a Sunday. It seemed that the location was popular as a lover's lane.

Perra's wife, Rose, had been in bed since shortly before he went missing. She was expecting their next child. Rose gave birth, and police waited to tell her of her husband's death because she was in serious condition after the birth of her fifth child. The Welfare Society and Visiting Nurses nursed the mother and baby while caring for the other four children. The family was left destitute by the death of Perra.

Police were searching for Walter Filkins, the man who was Perra's partner for the spotter job in Freeport. They were hoping he could shed some light on the motive for the killing. They also suspected that the partner might have told local bootleggers of Perra's true identity as a police spotter. Police never found Filkins, and Perra's murder was never solved.

The bootleggers in Rockford got very nervous after the deaths of Perra and McGill. There were also rumors that federal agents were

heading into Rockford for a "mop-up" campaign. The sellers were so cautious they turned customers away if there were any strangers in the area or the buyers were unfamiliar. There were also rumors that since it was suspected that some of the police force might be involved or at least warning the bootleggers of the raids, federal agents were working independently of local authorities.

The next time the guns roared, it was not a spotter they were aimed at. Gaetano DiSalvo, known as Tom DiSalvo, twenty-nine years old, owned a café at 1301 Seminary Street. He was a well-known racketeer who ended up at the wrong end of a gun. Tom's body was found on September 2, 1928, on the 200 block of Morgan Street, inside a car he had borrowed from another alleged gang member, Peter Salamone. DiSalvo was slumped over the steering wheel of the fancy LaSalle Roadster with nine steel jacket bullets inside his body. Police had a difficult time with this investigation because no one wanted to share any information. They uncovered the fact that DiSalvo had moved to Rockford a year before his death from Cleveland. He still had a brother in Akron, Ohio.

DiSalvo was finely dressed and had a large diamond ring on his finger and a diamond stickpin in his tie. DiSalvo carried a bankbook with entries that added to over $1,000. He also had papers that declared his intent to apply for citizenship. The papers stated that he moved to the United States from Italy in 1923.

Police questioned DiSalvo's supposed sweetheart, Lillian Tinney, who denied that they were lovers. Apparently, DiSalvo had a wife whom he left back in Italy. Lillian did admit she worked for him at his café and was in love with him. She claimed to have no idea why someone would kill him. Lillian was with DiSalvo on the night he was killed. DiSalvo took Lillian for a drive before dropping her off at home around six o'clock in the evening.

Others who remained nameless did admit to the police that DiSalvo was in the illegal alcohol business and that he had crossed another prominent local bootlegger and paid for it with his life. Another theory that was shared with police was that DiSalvo was killed as retaliation for the torture and murder of Tom Perra.

One thing was certain: when DiSalvo pulled the LaSalle Roadster up in front of the blacksmith shop on Morgan Street, there were at least two men waiting for him. One was probably on the sidewalk and engaged DiSalvo in conversation. Another man approached from the street and fired a bullet into the back of DiSalvo's head. Both men opened fire and shot eight more bullets into DiSalvo's body.

Only six people showed up for DiSalvo's funeral. Even his girl, Lillian, stayed away. The paper claimed that DiSalvo had no friends and no one mourned his death, except for maybe his little wife in Italy, who, not knowing of his brutal shooting, waited for his return.

17

PROHIBITION: DEATH ON THE STREETS

1928–1933

The police raids continued, and in 1930 a squad of federal agents was sent to the Rockford area. Agents from the United States Secret Service joined them. The Secret Service's main interest was one of the gang leaders in Rockford, Tony Musso. They later learned that he moved out to California, and they followed Musso there. The leader of the task force, C. Edson Smith, who was a deputy prohibition administrator from Chicago, was kept busy organizing the raids. The gangs were feeling the pressure from the federal squad raids and the regular police. In the beginning of June, one such gang opened fire on the federal agents.

The federal agents were conducting a raid on another house on Sanford Street. It was a suspected distillery, and the agents were dismantling the equipment when they were almost "mowed down by a shower of machine gun bullets." A car with curtains on the windows drove by, and suddenly there was the sound of machine gun fire. The bullets hit trees and the front of the house. No officers were hurt in this attack, but the act shocked the people of Rockford. "The mystery machine and the machine gunners were swallowed up by the night." No arrests were ever made for this shooting, though police suspected that Dominick Rossi, who lived at 710 Sanford Street, was involved with the attempt on the officers' lives.

On August 14, 1930, Joe Giovingo, a Rockford native, was standing on the curb by the corner of Morgan and South Main Streets talking to four men who were sitting in an automobile. One of the men was Tony Abbott. Abbott, whose real name was Abbatini, was reportedly part of Al Capone's

Gang from Chicago. Abbott allegedly killed one of "Bugs" Moran's men, Jack Zuta, in Wisconsin and was in Rockford hiding out.

As Joe was speaking to Abbott, two detectives standing on the sidewalk near the car called him over to question him. They wanted to talk to him about the recent raid at Giovingo's home on Harding Street. The officers were Folke Bengsten and Roy Johnson.

They had just started to talk to Joe when a large "high-powered" Dodge sedan appeared on South Main Street. As it passed Abbott's car, a shotgun was poked through the rear window, and shots were fired toward Abbott's car and the three men on the sidewalk. The bullets struck the car that Abbott was sitting in. Abbott and the other men in the car scrambled out of the doors and hunched behind the car. Johnson hit the ground, and Bengsten ducked and then drew his gun to return fire. The car continued south on South Main and then turned onto Montague Road. Joe had seventeen wounds from the gunshot blast that had torn into his side. One slug hit his elbow first and then passed into his abdomen. He died a few minutes later.

A photograph of the scene of Joe Giovingo's murder on South Main Street. *From Midway Village Museum, Rockford, Illinois.*

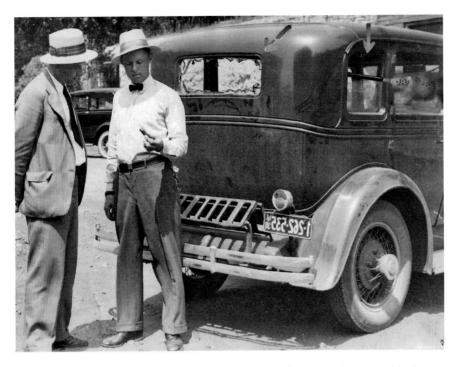

A photograph of Deputy Chester Pence and Roy Johnson inspecting the car used in the Giovingo killing. *From Midway Village Museum, Rockford, Illinois.*

The Dodge sedan was recovered the next day about a mile and a half from the city on Montague Road. This led the police to believe this was a premeditated hit. Bengsten and Johnson also reported that Abbott appeared nervous as he was sitting in his car prior to the attack. Abbott kept checking the rearview mirror as if looking for someone.

Police officers could not agree whether the bullets were meant for Abbott or Giovingo. Abbott and his bodyguards were taken into custody but later released. Family members of Giovingo would later say that Joe's murder was a case of mistaken identity. They stated they knew that Abbott was the intended target because Al Capone actually called the Giovingo house to speak to Joe's mother. Capone apologized that Joe had taken the bullet instead of the intended target.

Paul Giovingo, Joe's brother, came to the station to speak to police and then left with Abbott. Paul and Abbott were apparently good friends. Paul hosted his brother's funeral at his house at 1033 Montague Road. Joe's funeral was one of Rockford's largest, with over 1,500 people attending. There were 150 cars in the procession from the house to the Catholic

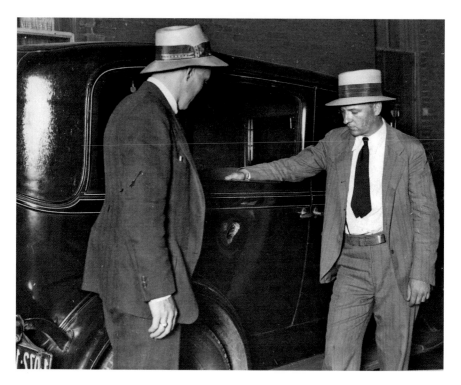

A photograph of Roy Johnson and Folke Bengsten inspecting the car Tony Abbott was sitting in when the shooting took place. *From Midway Village Museum, Rockford, Illinois.*

cemetery. The scene was mass chaos, as police officers, gang leaders, city officials, police officials, friends and family all wandered around the yard, waiting to leave for the funeral. Joe's mother and sister were hysterical, and their shrieking could be heard as the casket was loaded into the car. Members of the Italian Athletic Club acted as Joe's pallbearers.

Paul Giovingo would testify in September at an inquest about his brother's death, stating that Abbott was the true target of the assassin's bullets. Giovingo also told the jury that Abbott had recently been killed by the same men who had shot Joe. Paul, suspected to have gang ties himself, would soon become the subject of the police's interest.

Jack DeMarco was the next man to fall victim to the gang's retaliation. Jack DeMarco was born in Italy on November 28, 1891. He immigrated to the United States around 1917 when he was twenty-five years old. A suspected bootlegger, Jack DeMarco was in and out of trouble during the early part of the 1930s. He was arrested on suspicion that he was the leader in a stolen car ring and also several times for bootlegging and fighting. In

1928, he and the suspected leader of one of the bootlegging gangs, Tony Musso, were arrested when they were caught fighting in the street in front of the café where Joe Giovingo would later be killed.

In June 1930, DeMarco was operating a still from his home on Romona Avenue when he was arrested and sent with other defendants to Freeport to stand before Stanley M. Vance, United States deputy commissioner. The trial would be one of the most "spectacular trials in the history of Northern Illinois." Eighty men and one woman were charged with "conspiracy to violate the Prohibition Act." Fifty-nine of those arrested were sent to trial. The trial, conducted in Freeport, Illinois, started on January 12, 1931, and lasted until February 2. Thirty-six men were found guilty, twenty-eight of them were sentenced to prison and the rest were either given short-term sentences or placed on probation. The names of the men sentenced are: John Alto, Joe Baraconi, Joe Bendetto, Joe Fizula, Frank Theodore, Andrew Saladino, Tony Giovingo, Paul Giovingo, Frank Rumore, Theodore LaFranka, Louis Verace, Joe Stassi, Thomas Rumore, Tony Musso, Joe Domino, Alfred Falzone, Lorenzo Buttice, Tony Carleto, Frank Buscemi and Peter Sanfillipo. DeMarco would be sent to Leavenworth to serve twelve months of an eighteen-month sentence. It was while serving his time at Leavenworth that rumors started to spread about one of the twenty-eight men talking to the federal agents.

Rockford woke on January 20, 1932, to headlines that announced that gunfire had once been again heard in the southwest neighborhood. "Gangland guns, still in Rockford for the last year, roared a leaden greeting of death to Jack DeMarco, forty six, a local bootlegger at his home at 7 o'clock last night."

The story went on to say that DeMarco, who had been released from Leavenworth penitentiary the day before, was killed in his own home on Romona Avenue. Jack's family and friends were hosting a welcome home party when three well-dressed men knocked on the kitchen door and asked to speak to Jack. They flashed badges and were admitted into the home.

Jack was in the dining room placing another record on the Victrola when the men entered the room. All three pulled guns, stated they were the police and asked to speak to Jack alone. One of the men shepherded the family members into a bedroom while another watched the kitchen door. The third man walked DeMarco into the living room. Jack had just enough time to state, "You're no sheriff or police" before the man opened fire. Three shots roared from the gun in quick succession followed by two more. The next sounds the family members heard were running feet and a car roaring away.

They crawled out of the bedroom window and ran for safety. Sam Correnti, a neighbor and friend of the DeMarco family, bravely poked his head into the living room.

The autopsy revealed that Jack had been shot once in the back, once in the back of the head, and then after he fell, he was shot twice through the left ear. One bullet lodged in the floor next to DeMarco's head. All shots came from a .45-caliber revolver.

Jack had only been home for ten hours. His wife, Fannie, was devastated by the loss of her husband. She was too hysterical to be questioned by police. Coroner Walter Julian and State's Attorney Karl Williams read the letters that Fannie received from Jack during his time at Leavenworth looking for clues about who might have wanted him dead.

Undertaker F.S. Long conducted the funeral inside DeMarco's home on January 22, 1932. The little band of mourners made its way to the cemetery, where the coffin was opened for a final goodbye. Fannie DeMarco, who spent most of the funeral moaning, suddenly hurled herself into Jack's coffin and, for the last time, kissed his lips. Sobbing uncontrollably, she was carried back to the car by her family.

The *Register Republic* article stated, "A lone sexton silently lowered the casket into the grave. The last tragic chapter had been written to Jack DeMarco's 'home-coming' from Leavenworth, a brief celebration terminated by five bullets from the guns of gangland's executioners last Tuesday night." DeMarco's murderers were never caught.

Paul Giovingo was another of the Rockford bootleggers to be sent to the Leavenworth penitentiary. He was sentenced to two years and was released in the fall of 1932. A lot had changed in Rockford during the time he was away. Since that indictment had cleared many of the small dealers out of way in the illegal liquor business, the much larger, better organized and more powerful liquor syndicates from Peoria, Springfield and southern Wisconsin swept in to take control.

Giovingo was using strong-arm "buy your liquor from me or else" tactics and kept running into resistance from the local speakeasies. The tensions were building, and trouble seemed imminent. Things came to a head on February 12, 1933. At around 7:00 p.m., Giovingo went to get his shoes shined at Midway Shoe Shine Parlor on East State Street.

When Giovingo left the parlor, he stopped at his house at 1033 Montague Street to visit with his wife and children. He shaved and changed his suit before he left his house on the way to his "exclusive" speakeasy on South Main Street.

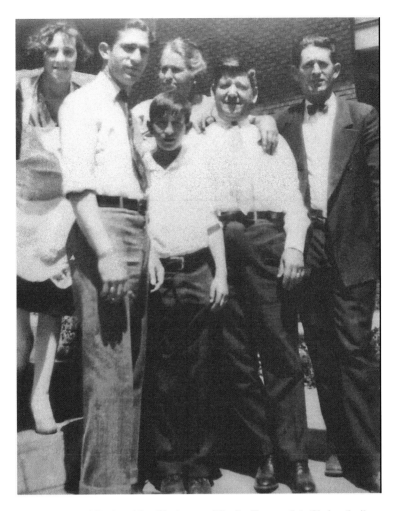

A photograph of Paul and Joe Giovingo and family. *Courtesy of the Giovingo family.*

Paul never reached his destination. He must have suspected that something bad was coming because when police found his body, his gun, though unfired, was in his hand. There was supposedly a letter that had been delivered to the house the day before, warning Paul that he should stay home that night. Giovingo was only a block from his home on South Winnebago Street when his time finally ran out. His car had been forced against the curb between Loomis and Montague Streets and was riddled with shotgun and revolver blasts on the driver's side and back of the car. Paul's body had eight slugs in his left side and there were four gunshots to his head. His car was found next to the curb with the ignition turned off and the emergency brake set.

The killers must have wanted to ensure Paul's death because evidence showed they stopped the car and fired several revolver shots to the back of his head. Powder marks indicated that these were contact wounds.

Even though a large crowd of people gathered at the death scene, no one could or would tell the police anything. The police talked of it like coming up against a wall—a wall of silence. The assistant chief of police, Homer Read, and police captain Charles Manson involved themselves in the investigation right from the beginning, but nothing could penetrate the wall. The investigation that started out very slow quickly ground to a complete stop.

The motive for the shooting was very clear. The *Morning Star* newspaper stated, "Giovingo's career has been linked closely to the rise and fall of the liquor industry in Rockford. Paul was first known in Rockford as a barber, affable and efficient, and with a large following. Then the easy profits of the liquor business became apparent to him and he abandoned his trade to become a bootlegger."

This was a decision that he would not live to regret. The regret would be carried by his family, a mother who had already buried one son due to violence and his wife, who was left to raise their two young sons, Sam, seven, and Elmer, five.

Even before Paul Giovingo died, the illegal booze racketeers were feeling the pressure from within and without. The rival gangs had just about killed each other off, and the police were using the fact that the people of Rockford were tired of all the violence on their streets. The writing was on the wall.

The Twenty-first Amendment that repealed the Eighteenth Amendment (also known as the Prohibition Act) was submitted to the states on February 20, 1933, and was ratified on November 7, 1933. The illegal liquor business was, for all intents and purposes, finished. The violence in the streets of Rockford, unfortunately, was not.

BIBLIOGRAPHY

The research for these stories has taken place over ten years. Since the primary source of information was local news accounts, there will obviously be some incomplete information. Every attempt has been made to corroborate with different sources.

INTRODUCTION

Church, Charles. *History of Rockford and Winnebago County, Illinois*. Rockford, IL: W.P. Lamb, 1900.

CHAPTER 1

Baltimore (MD) Sun. "A Sheriff Shot in Illinois." November 13, 1856.
New York Tribune. "A Sheriff Shot in Illinois." November 12, 1856.
Rockford (IL) Republic. "Shocking Tragedy in This City." November 13, 1856.
Rockford (IL) Weekly Register. "Tragedy of Tuesday." November 15, 1856.
Rock River (IL) Democrat. "Countryman Sentenced." March 10, 1857.
———. "Execution of Alfred Countryman." March 31, 1857.
Washington, D.C., Daily Union. "A Sheriff Shot in Illinois." November 15, 1856.

CHAPTER 2

Chicago Daily Inter Ocean. "Mourners Become a Mob." September 9, 1893.
———. "Slays His Sisters." September 6, 1893.

BIBLIOGRAPHY

Rockford (IL) Daily Register Gazette. "Hart Hanged." March 16, 1894.

———. "John Hart's Past Record." September 16, 1893.

Rockford (IL) Morning Star. "A Batch of Crooked People." October 10, 1893.

———. "Desperate Attempt to Break Jail." November 1, 1893.

———. "Foul Murder." September 6, 1893.

———. "Funeral for the Murdered Sisters." September 9, 1893.

———. "Hart Declares War Against His Family." September 11, 1893.

———. "The Murderer Attempts Suicide." December 17, 1893.

———. "Proves to Be a Double Murder." September 7, 1893.

Chapter 3

Rockford (IL) Daily Register Gazette. "Bids Her Goodbye." June 7, 1897.

———. "Deed of a Demon." July 20, 1896.

———. "James French on Trial." May 4, 1897.

Rockford (IL) Morning Star. "Crime of a Monster." July 20, 1896.

———. "First Plea Is Made." May 13, 1897.

———. "His Plea Not Guilty." October 13, 1896.

———. "Hour at Hand." June 11, 1897.

———. "James French Feels No Remorse for His Terrible Crime." July 21, 1896.

———. "A Life of Sorrow." July 20, 1896.

Rockford (IL) Republic. "French's Holiday." May 29, 1897.

———. "French Will Hang." May 14, 1897.

———. "The Murderer Talks." July 23, 1896.

———. "Paid the Penalty." June 11, 1897.

Chapter 4

Rockford (IL) Daily Register Gazette. "He Ended Two Lives." August 16, 1898.

———. "Jack Ennett on a Rampage." December 28, 1914.

———. "Stiff Fine for Ennett." December 19, 1910.

———. "Thomas Ennett Is No More." June 15, 1908.

Rockford (IL) Daily Republic. "Horrible Double Tragedy: Geo. Ennett's Awful Crime." August 16, 1898.

———. "Inquest Held Over Bodies." August 17, 1898.

Rockford (IL) Morning Star. "Aged Fisherman Dies Trundling Boat Home." October 25, 1944.

———. "Death Summons Miss Mary Ennett Saturday Evening." November 30, 1930.

———. "Fall Fatal to Elderly Man." January 11, 1947.

———. "John Ennett Dies, Aged 80; Rites Friday." June 7, 1951.

———. "Killed Sister and Himself." August 17, 1898.

———. "Mrs. Perkins to Be Buried on Saturday." April 17, 1959.

———. "Mrs. Thomas Ennett Taken." January 29, 1897.

BIBLIOGRAPHY

————. "Nellie Ennett Is Bride." December 19, 1912.

————. "Will Be Buried Today." August 18, 1898.

Rockford (IL) Republic. "Ennett Death a Suicide, Jury Here Decides." December 9, 1924.

————. "Fred Ennett Is Dead at St. Anthony." December 2, 1924.

————. "Man Missing Since '17 Declared Legally Dead." December 4, 1947.

————. "Tom Ennett Falls 20 Feet." December 2, 1904.

Chapter 5

Duluth (MN) News-Tribune. "Child Murderer Lands in Prison." March 20, 1904.

Rockford (IL) Morning Star. "Dick Tebbets Murdered and His Body Horribly Mutilated. and No Clue to Fiend Who Did It." July 1, 1903.

————. "Murderer of Dick Tebbets Identified by Photograph." August 25, 1903.

Rockford (IL) Republic. "Awful Crimes Are Alarming Policemen." August 19, 1903.

————. "Emil Waltz Lived in Rockford One Week." October 1, 1903.

————. "Suicide Avenges Dick Tebbets Murder." July 24, 1905.

Chapter 6

Rockford (IL) Daily Register Gazette. "St. Clair Will Enter a Plea of Not Guilty." January 25, 1910.

————. "Trace Blood Tracks for Many Blocks." January 20, 1910.

Rockford (IL) Morning Star. "Death of Mrs. Laing May Be Laid at Door of St. Clair." January 22, 1910.

————. "St. Clair Buried Soon After Noon." April 16, 1910.

————. "St. Clair Tells How He Slew Aged Woman." January 21, 1910.

Rockford (IL) Republic. "Clinton St. Clair Hanged at 8:30." April 15, 1910.

————. "Does Ghost of Clinton St. Clair Lurk Around Jail Corridors?" May 14, 1910.

————. "Mrs. McIntosh Owned $10,000." February 1, 1910.

————. "Queer Mad Fits to Be Defense for St. Clair." January 24, 1910.

Chapter 7

Rockford (IL) Daily Register Gazette. "Fate Cheated Maher's Gun of 2 Victims." February 12, 1924.

————. "Jilted Youth Slays Girl; Shoots Self." February 5, 1924.

Rockford (IL) Morning Star. "Funerals for Love Victims Held Thursday." February 6, 1924.

————. "Love Crazed and Spurned." February 5, 1924.

Rockford (IL) Republic. "Tearful Tributes for Mary Ostrowski Today." February 7, 1924.

————. "Tragic End of Romance Told Jury." February 12, 1924.

BIBLIOGRAPHY

CHAPTER 8

Rockford (IL) Morning Star. "Brady Home Dark, Hushed; Friends Offer Sympathies." February 15, 1966.

————. "Car Led Police to Suspect Dewey in Disappearance." February 15, 1966.

————. "Describes Susan's Death as Nightmare." February 18, 1966.

————. "Dixon Fireman Aid in the Hunt for Susan Brady." December 29, 1965.

————. "800 Attend Memorial Mass for Susan." February 22, 1966.

————. "Hearing Today for Dewey." February 18, 1966.

————. "Hunt for '61 Cadillac in Brady Case." January 9, 1966.

————. "Probe Hammer in Brady Death." February 15, 1966.

————. "Pupils Pray for Susan; Recall What Kind of Person She Is." December 23, 1965.

————. "Yule Tree Stands as Symbol of Hope for Brady Family." January 12, 1966.

Rockford (IL) Register Republic. "Brothers Told Susan Dead; Mass Offered." February 14, 1966.

————. "Dewey Testifies, Calls Killing Accidental." August 19, 1966.

————. "Incinerator Held Charred Remains." February 14, 1966.

————. "Laskey to Ask New Dewey Trial." August 22, 1966.

————. "Man Held for Murder in Susan Brady's Death." February 14, 1966.

————. "Mother Keeps Sad, Long Vigil." December 22, 1965.

————. "Priest 'Don't Grieve for Susan.'" February 22, 1966.

————. "Schoolmates Pray for Safe Return." December 22, 1965.

————. "Searchers Unable to Turn up Clues." December 22, 1965.

————. "Sleepless Father Tells Story." December 22, 1965.

————. "St. Patrick Youngsters Remember Susan at School." November 19, 1974.

————. "State Ends Case in Dewey Trial." August 18, 1966.

————. "Widen Hunt for Lost Girl." December 22, 1965.

Rockford (IL) Register Star. "20 Years Later Girl's Killer to Be Freed." February 24, 1987.

Rockford (IL) Republic. "Brady's Ask for Prayers for Susan." December 24, 1965.

————. "Search for Susan, Phone Tips Go On." January 12, 1966.

CHAPTER 9

Rockford (IL) Morning Star. "Boys' Slaying Draws Newsmen to Rockford." March 4, 1967.

————. "Charge Youth as 'Executioner.'" March 7, 1967.

————. "Clues Sifted in 'Execution.'" March 4, 1967.

————. "Coach Had Plans for Slain 'Chuck.'" March 4, 1967.

————. "Mayor Says All Must Uphold Law." March 7, 1967.

————. "Neighbors of Boys Stunned by Killings." March 4, 1967.

————. "Obituary—'Williams, John Wesley.'" July 6, 1972.

————. "$1,000 Added to Reward by Chamber." March 7, 1967.

————. "Robert 'Chuck' Johnson Obituary." March 4, 1967.

————. "Robert Wayne Mullendore Obituary." March 4, 1967.

————. "Salesman Testifies that He Sold a Revolver to Murder Suspect." June 28, 1967.

BIBLIOGRAPHY

————. "Slayings of 2 Young Boys, Sadden Friends, Neighbors." March 4, 1967.

————. "2 Murdered Boys Buried Side by Side." March 7, 1967.

————. "Williams Held for Grand Jury." March 9, 1967.

————. "Williams, Killer of Two, Hangs in Jail." July 5, 1972.

————. "Yule Is Lonely; Father Misses His Son." December 22, 1973.

Rockford (IL) Register Republic. "State Court Upholds Williams Conviction." September 24, 1967.

————. "Williams Gets 90–100 Years." September 14, 1967.

CHAPTER 10

New York Tribune. "A Courthouse Falls in Ruins." May 12, 1877.

Rockford (IL) Morning Star. "First Courthouse Built without Public Funds." November 15, 1969.

Rockford (IL) Weekly Gazette. "Courthouse Disaster." May 24, 1877.

————. "Horror Stricken." May 17, 1877.

————. "Rockford's Calamity." May 18, 1877.

CHAPTER 11

Rockford (IL) Republic. "Another Lost in Wreck." December 19, 1901.

————. "Condition of Injured Men." December 19, 1901.

————. "Hospital Corps Kept Busy." December 16, 1901.

————. "Many Miraculous Escapes from Wreckage." December 16, 1901.

————. "Nine Killed and Many Injured in Terrible Head On Collision." December 16, 1901.

————. "Romance of the Big Wreck." December 16, 1901.

————. "Scenes of Sorrow in the Homes." December 16, 1901.

————. "Turner Turns Up Alive." December 16, 1901.

————. "Wreck Victims Tenderly Cared for at Hospital." December 16, 1901.

CHAPTER 12

Rockford (IL) Daily Register Gazette. "8,500 to Reach Camp Grant August 10." July 24, 1925.

Rockford (IL) Morning Star. "Almost All Howitzer Company of Eighth Infantry Among Casualties." August 25, 1925.

————. "City to Honor Howitzer Dead." August 28, 1925.

————. "Honor Dead of Eighth Today." August 30, 1925.

————. "Monster Floral Gun to Express Feeling of City." August 29, 1925.

————. "Resume Quiz in Blast Deaths at Camp Today." August 26, 1925.

————. "Seventeen Hurt by Grenades." August 25, 1925.

————. "35,000 Turn Out for Rites of Camp Grant." September 1, 1925.

———. "Victims of Camp Blast Taken Home." September 13, 1925.

Rockford (IL) Republic. "Bomb Fire Burns 18 at Camp." August 24, 1925.

———. "Camp Grant Lives Again." August 17, 1925.

———. "Howitzer Lets Go at Drill." August 24, 1925.

———. "7 Soldiers Killed, 31 Maimed in Cannon Blast at Camp Grant." August 24, 1925.

CHAPTER 13

Rockford (IL) Daily Register Gazette. "Girl May Lose Sight of an Eye." April 22, 1926.

———. "Sutton Victim Kin Wins $1650.00." October 20, 1926.

———. "To Probe Holocaust." May 29, 1926.

Rockford (IL) Morning Star. "Jurors Demand Stricter Rules in Fire Hazards." June 2, 1926.

———. "Sutton's New Plant Modern in All Details." October 22, 1926.

Rockford (IL) Republic. "Arrange Funerals of Five Fire Victims." May 29, 1926.

———. "Launch Two Probes into Top Shop Holocaust; Five Dead." May 29, 1926.

CHAPTER 14

Rockford (IL) Morning Star. "Contractors Lend More Apparatus to Help Remove Wreckage." September 16, 1928.

———. "Movies of Havoc Caused by Storm Shown at Palace." September 16, 1928.

———. "Triple Funeral Is Arranged for Boys Killed in Tornado." September 16, 1928.

Rockford (IL) Republic. "Recover Six Bodies from Factory Ruin." September 17, 1928.

———. "60,000 Fed in Cafes Sunday; Food Runs Out." September 17, 1928.

———. "Storm Drops Violence on Three Areas." September 14, 1928.

———. "Storm Tore Freak Path Across City." September 15, 1928.

———. "Whole City Anxious to Aid Victims." September 17, 1928.

CHAPTER 15

Rockford (IL) Daily Register Gazette. "Bootlegger Is Fined $1,000 and Draws 60 Days." June 23, 1921.

———. "Drinker Is Found Dead; Hunt Seller." May 5, 1922.

———. "Moon Too Cheap in the Tri-Cities." January 10, 1922.

Rockford (IL) Morning Star. "Post Mortem Mutimer Body Causes Stir." May 6, 1922.

———. "Soldier Wanted a Drink of Liquor, Not Poison." July 1, 1920.

Rockford (IL) Republic. "Man's Head Almost Slashed from Body." October 8, 1923.

———. "Moonshine Egg." June 10, 1921.

———. "Rival Slew Milani." October 16, 1923.

BIBLIOGRAPHY

CHAPTER 16

Rockford (IL) Daily Register Gazette. "Hint Gambling Is Motive in Local Slaying."
October 12, 1925.

———. "Take Alky in Night Raid." December 3, 1925.

———. "Tragedy Ends Scuffle Over Unloaded Gun." December 31, 1923.

———. "Trap Four in Pre-Holiday Liquor Raids." December 3, 1925.

Rockford (IL) Republic. "Big Jim Diverno Hiding in Cicero, Police Hear." March
9, 1928.

———. "David Dotz Spends Morning on Stand." May 12, 1927.

———. "Fear More Liquor Gunfire Here." September 23, 1926.

———. "Gangland Code Seals the Lips of Girl Witness." September 5, 1928.

———. "Gangland Guns Blaze Death to Racketeer." September 4, 1928.

———. "Hooch Sells at $7.00 a Pint." September 29, 1920.

———. "Nine Shots Fired into Man's Body." September 4, 1928.

———. "Not Guilty Verdict in Three Hours." May 27, 1927.

———. "Oddo Swears Killing Was Accidental." February 7, 1924.

———. "Pals Desert Murdered Racketeer at Funeral." September 8, 1928.

———. "Rockford Has Seven Unsolved Deaths on Records." August 17, 1930.

———. "Search for Slain Man's Pal Futile." February 7, 1928.

———. "Sheriff Raids Three Alleged Liquor Resorts." May 9, 1931.

———. "Shotguns Roar in War Against Booze." September 23, 1926.

———. "Truckload of Liquor Seized." November 19, 1925.

———. "Victim Taken for a Ride and Shot to Death." February 6, 1928.

———. "Wife Promises Decent Burial for Slain Man." February 3, 1928.

CHAPTER 17

Rockford (IL) Morning Star. "Federal Seize Still and Owner in Beloit." June 13, 1930.

———. "Gang Dictator Slain Here." February 12, 1933.

———. "Jack DeMarco Shot to Death Here." January 20, 1932.

Rockford (IL) Register Republic. "Smiles Mingle with Tears as 21 Go to Prison." February
21, 1931.

Rockford (IL) Republic. "Hunt for Owner of Death Car Here." August 16, 1930.

———. "Local Man Slain from Death Auto." August 15, 1930.

———. "Murder Marks New Chapter in Old Liquor Feud." January 20, 1932.

———. "Paul Giovingo Is Victim of Alky Gunmen." February 13, 1933.

———. "Wife of Gangland Killer Victim Collapses at Grave Site." January 22, 1932.

ABOUT THE AUTHOR

Kathi Kresol has been researching Rockford's history for the past ten years. She shares the fascinating stories she uncovers through her website at www.hauntedrockford. com, her "Voices from the Grave" column in the *Rock River Times* weekly newspaper and through her Haunted Rockford Tours. Kathi's obsession is history, and she loves the opportunity to share this passion through the stories she collects. Kathi is a member of Rockford Historical Society, has worked at the Rockford Public Library for years and loves sharing

Courtesy Aryn Kresol Photography.

her enthusiasm for history and reading in any way possible. Along with researching and writing about history, Kathi has given presentations on true crime cases, paranormal encounters and Rockford history. She has also been interviewed for several radio shows, local newscasts and newspapers and always considers it an honor to share the stories of the men, women and children who have called Rockford home.